SECOND SLICE

The Art of OLIVIA

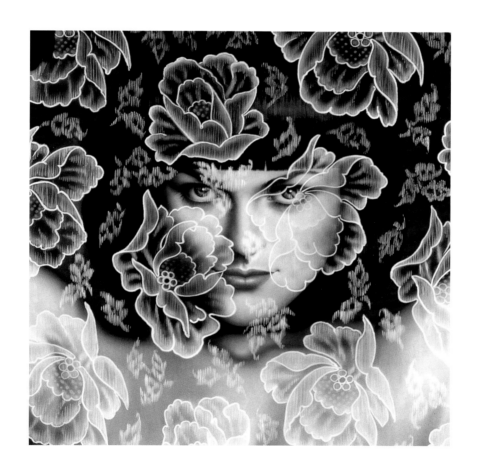

Ozone Productions, Ltd.

Acknowledgements

Olivia and Joel want to take this opportunity to thank these friends.

Allan Adel, Erika Andersch, Jenny and Danny Applebaum, Steve Baim, Robert and Tamara Bane, Michael Baron, Dr. Irvin and Sara Lee Beren, Jason and Eric Beren, Blayne, Brendan, Lyniese Burks, Darla Crane, Cindy Daguerre, Connie and Sante De Berardinis, Kevin Eastman, Cheryl and Wendall Eugenio, Rebecca Ferratti, Ellen Fox-Gaetani, Steve Fransen, Jenny French, Monique Gabrielle, Marilyn Grabowski, Hugh and Kimberly Hefner, Terri Nicole Hess, Jack Holke, Florice Houde, Jia Ling, Howard Jorofsky, Kata, Michael Kley, Pamela Lee, Ira Levine, Mario Lopez, Walter Luhr, Lillian Müller, Shauna O'Brien, Bettie Page, Jim Papadakis, Wyatt Portz, Linnea Quigley, Rhonda Ridley, Pam Roberts, Blanche Roberts, Hank Rose, Jeff Rund, Rhonda Rydell, Bella Schol, Rhonda Shear, Hajime Soroyama, Charles Stanton, Julie Strain, George Tai, Sandra Taylor, Tracy Tweed, Joseph Vasta, Charles Zarett

Credits

This book has been compiled, edited, and designed by Joel Beren, with the unlimited assistance of Olivia.

SECOND SLICE
The Art of Olivia
Copyright © 1997 by Olivia De Berardinis

Ozone Productions, Ltd.
P.O. Box 4153
Point Dume Station
Malibu, CA. 90265

For information concerning publishing and licensing rights, contact Ozone Productions, Ltd. or contact:

O Cards
P.O. Box 111
Roslyn, N.Y. 11576
Phone: (516) 621-8484
FAX: (516)625-8715

Printed and bound in Hong Kong by Regent Publishing Services Limited.

ISBN #0-929643-07-0
First Edition
10 9 8 7 6 5 4 3 2 1

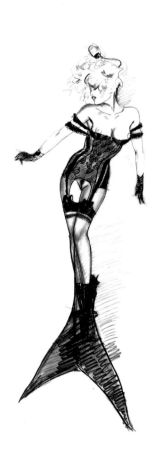

SECOND SLICE

The Art of OLIVIA

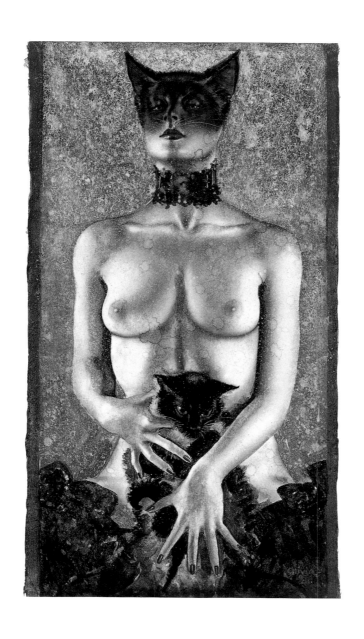

Ozone Productions, Ltd.

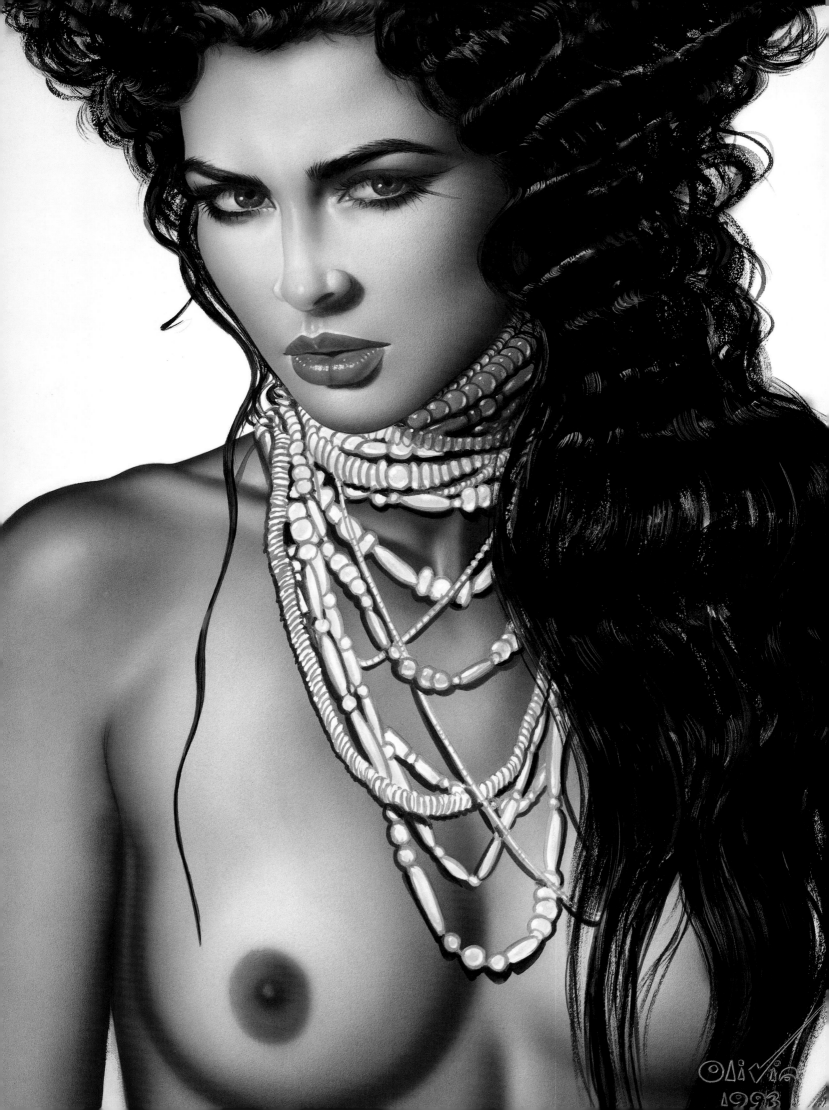

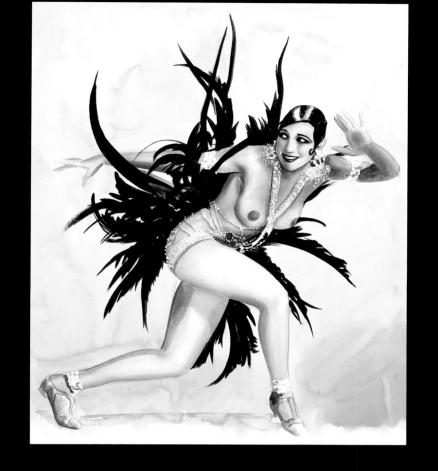

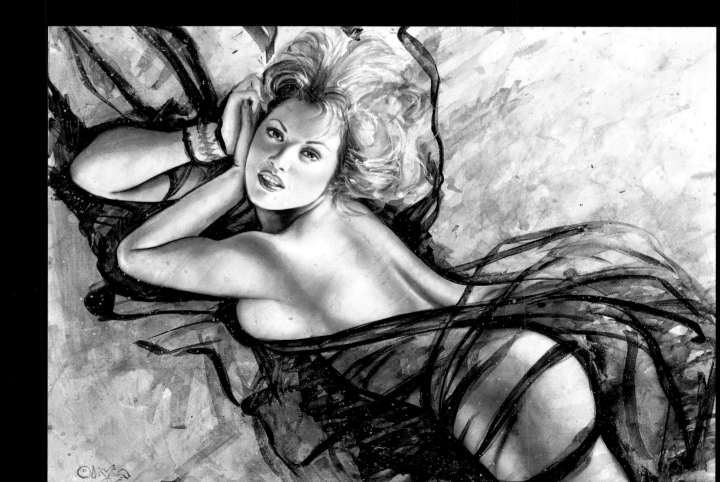

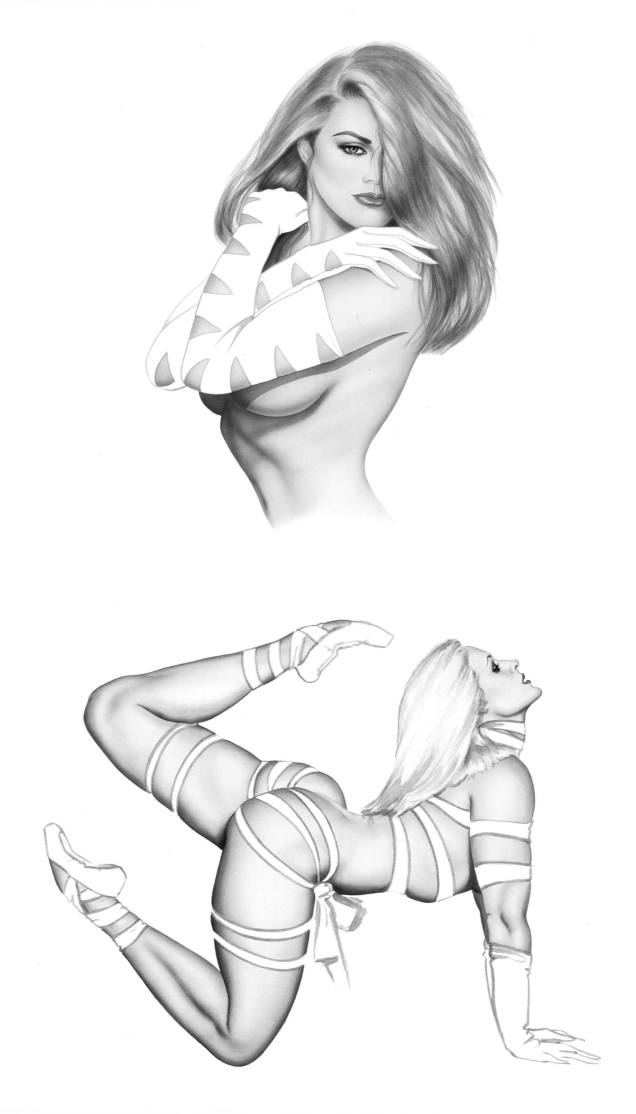

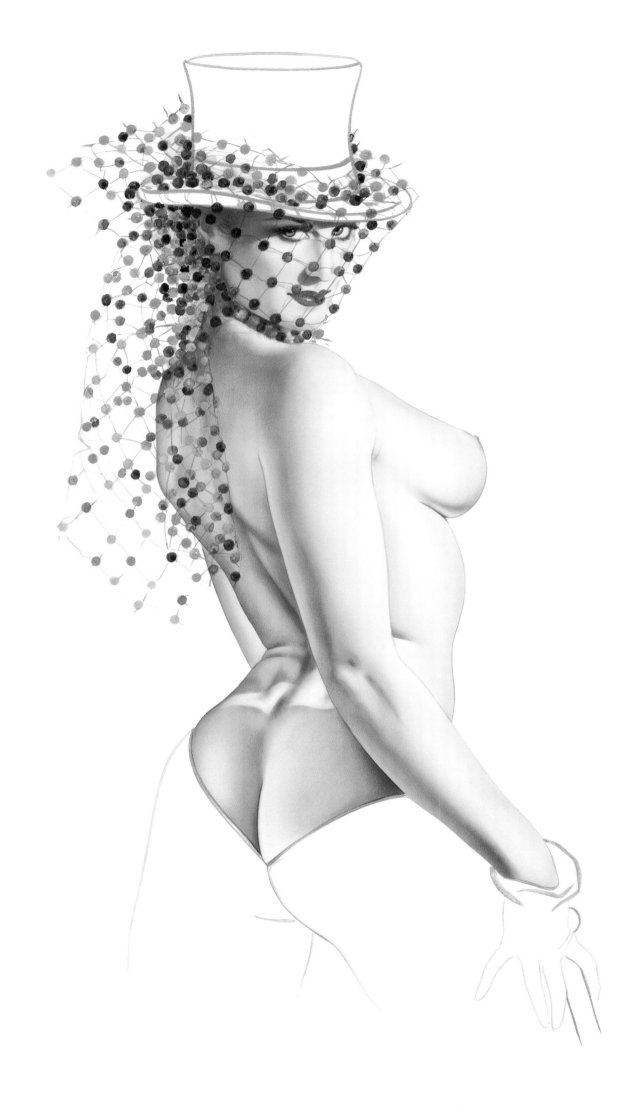

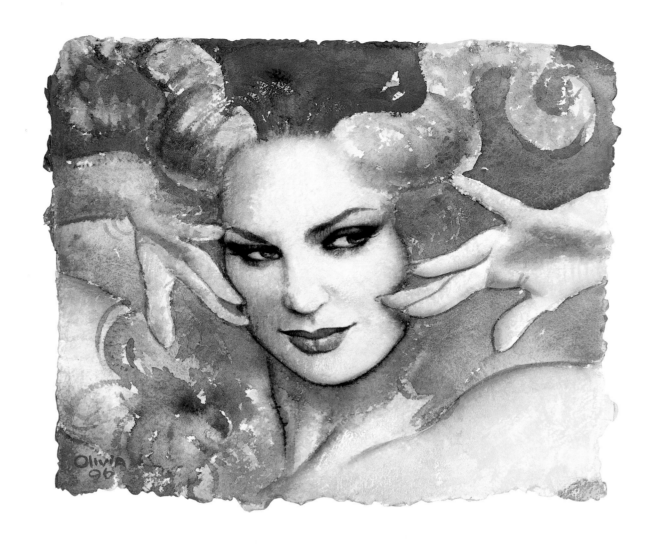

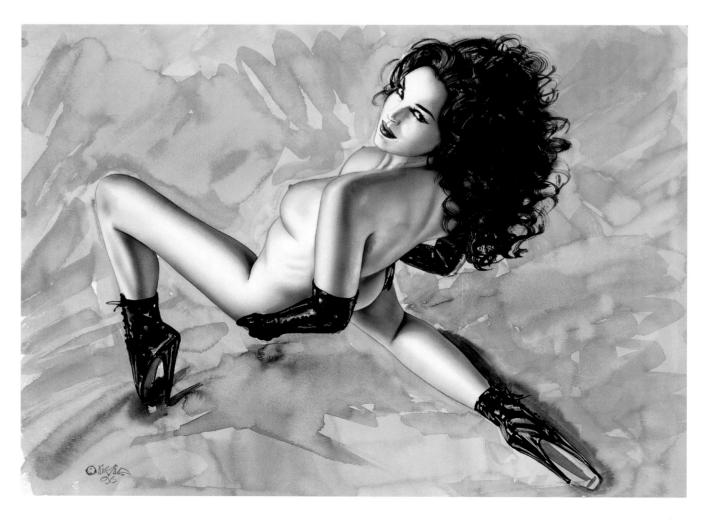

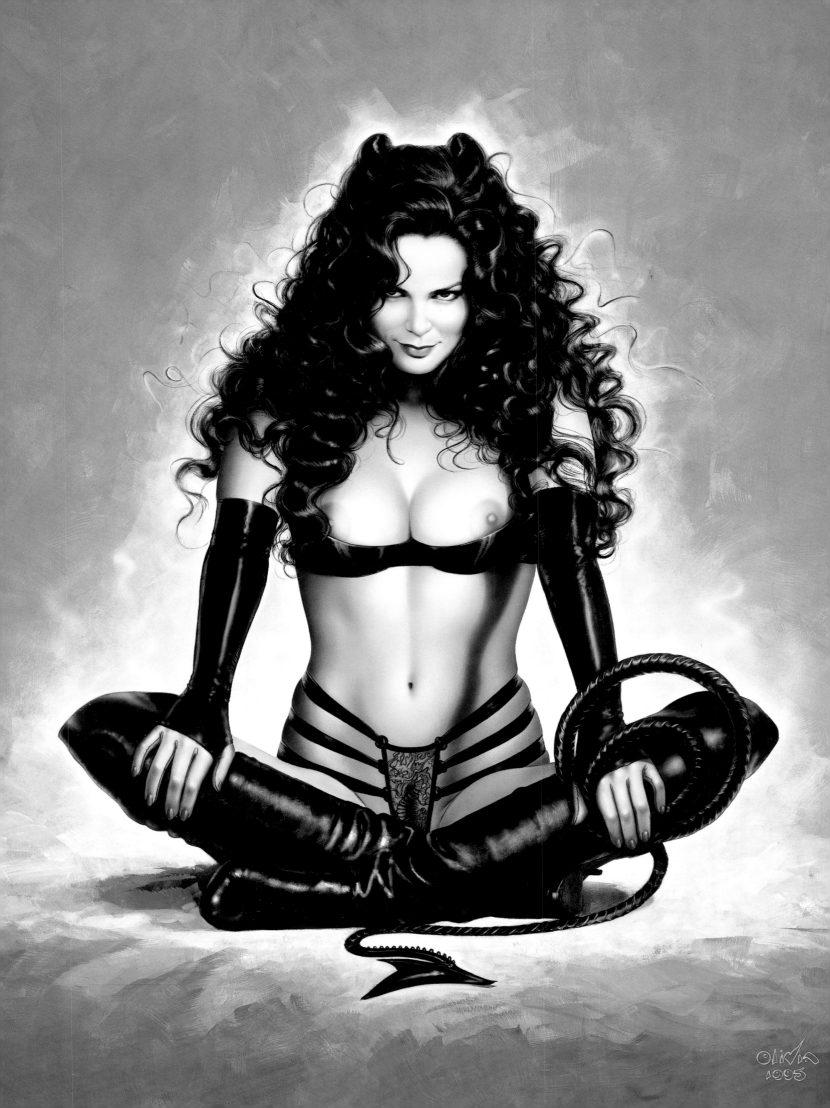

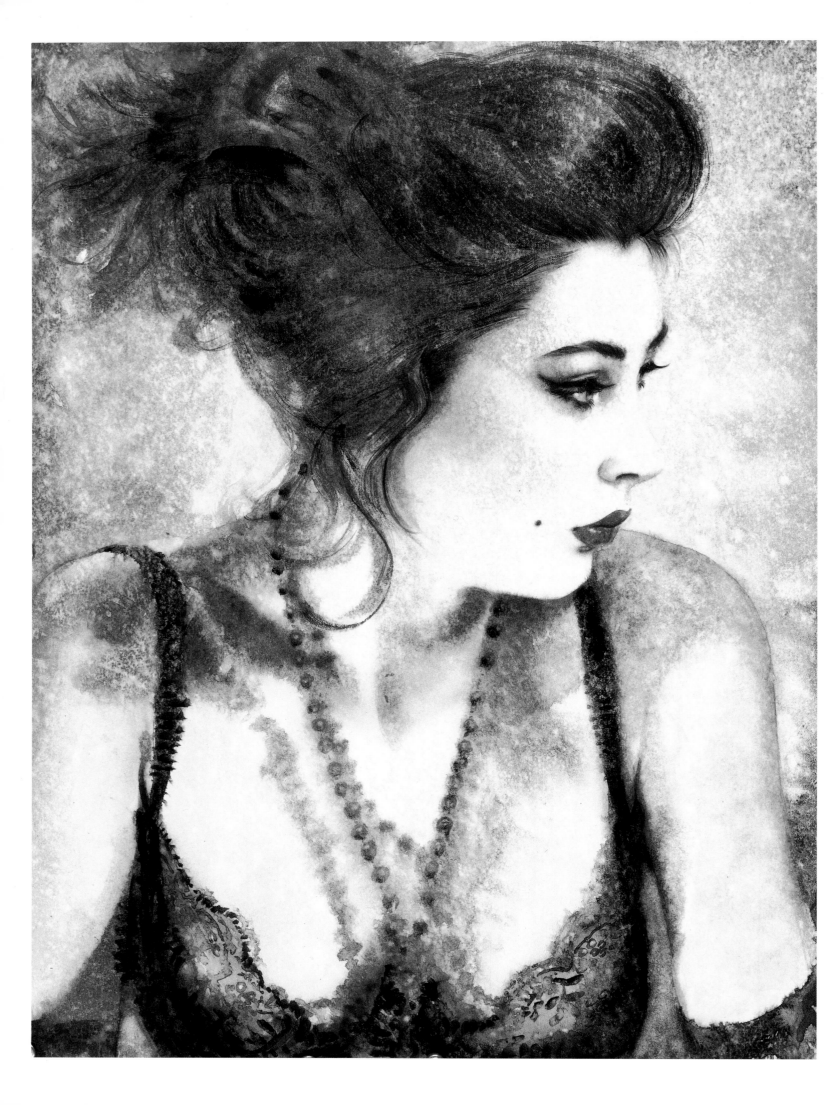

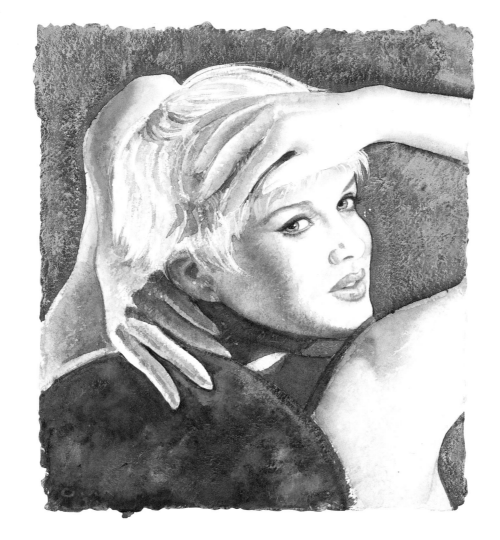

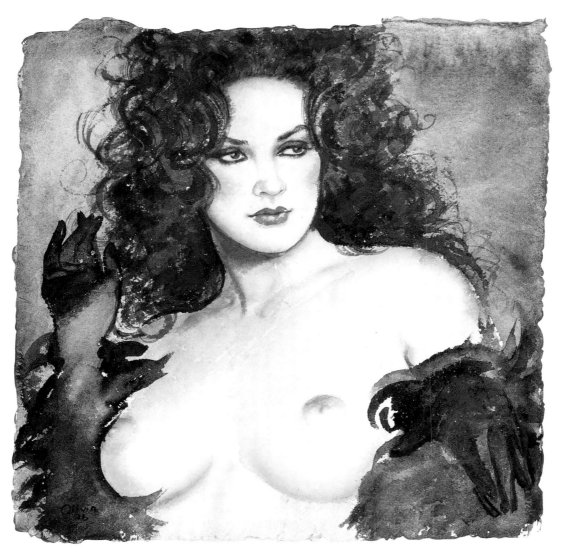

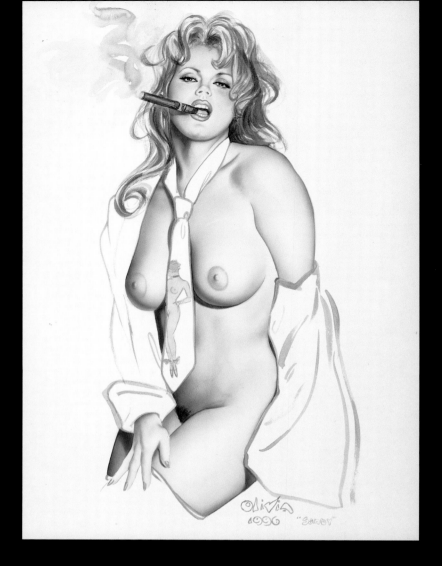

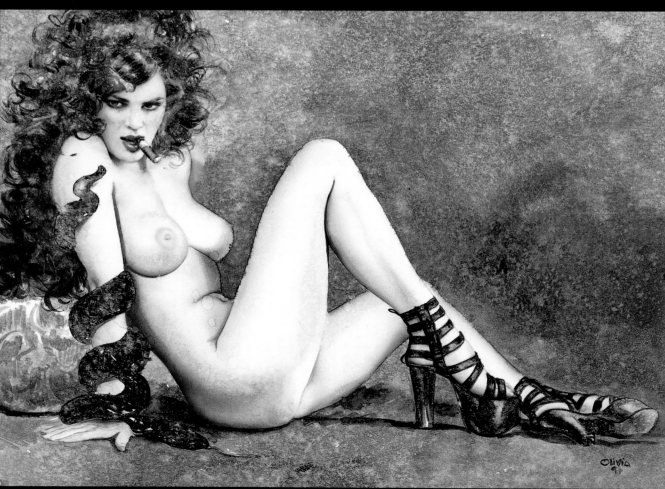

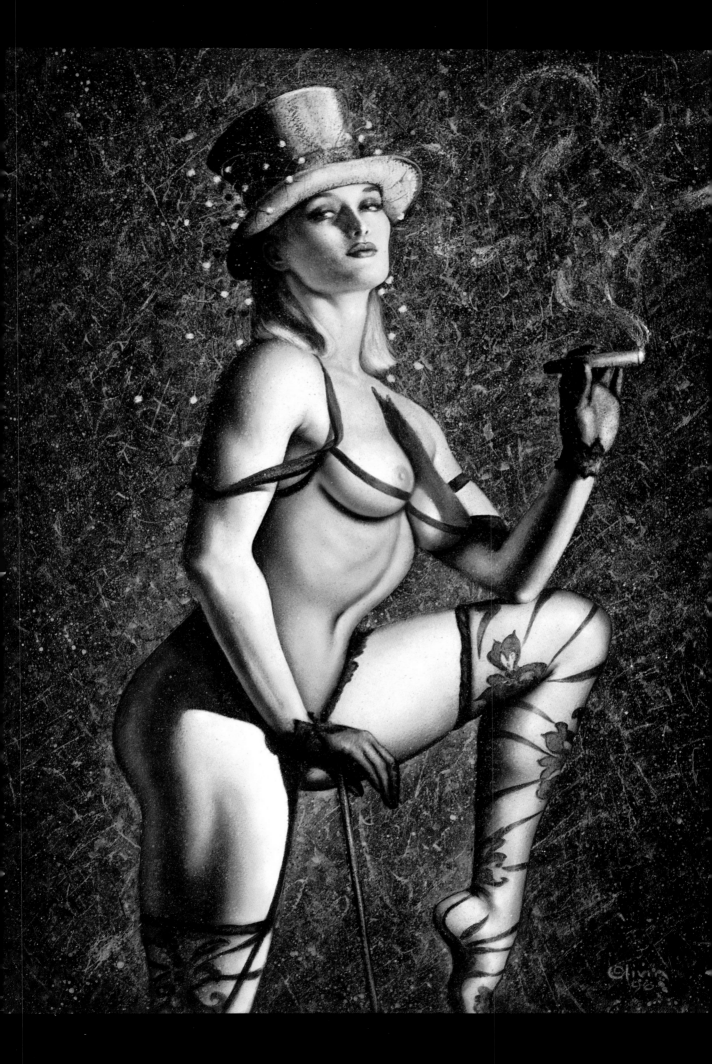

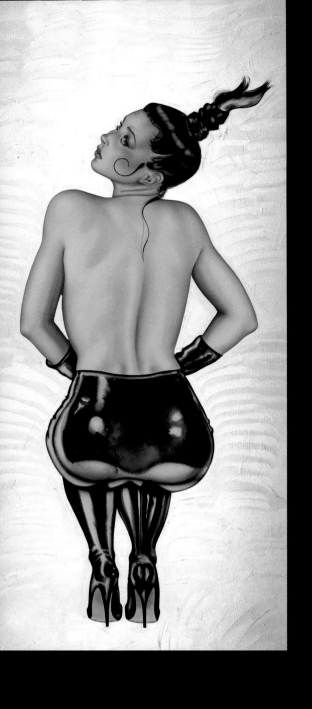
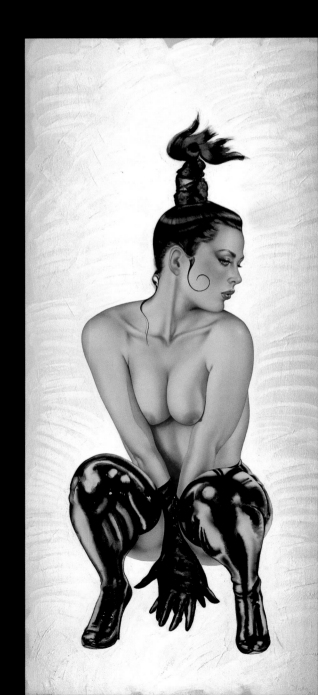

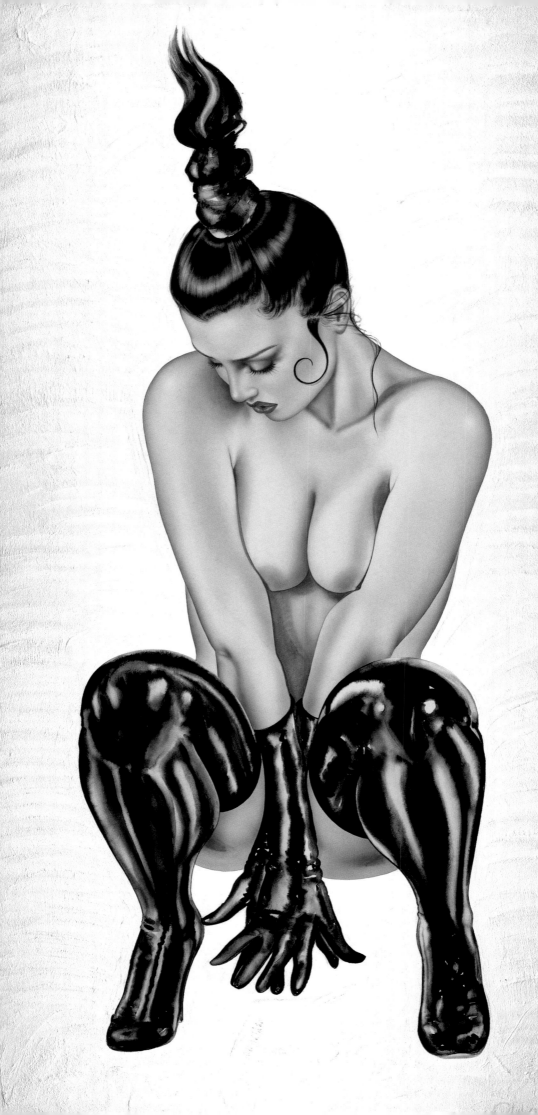

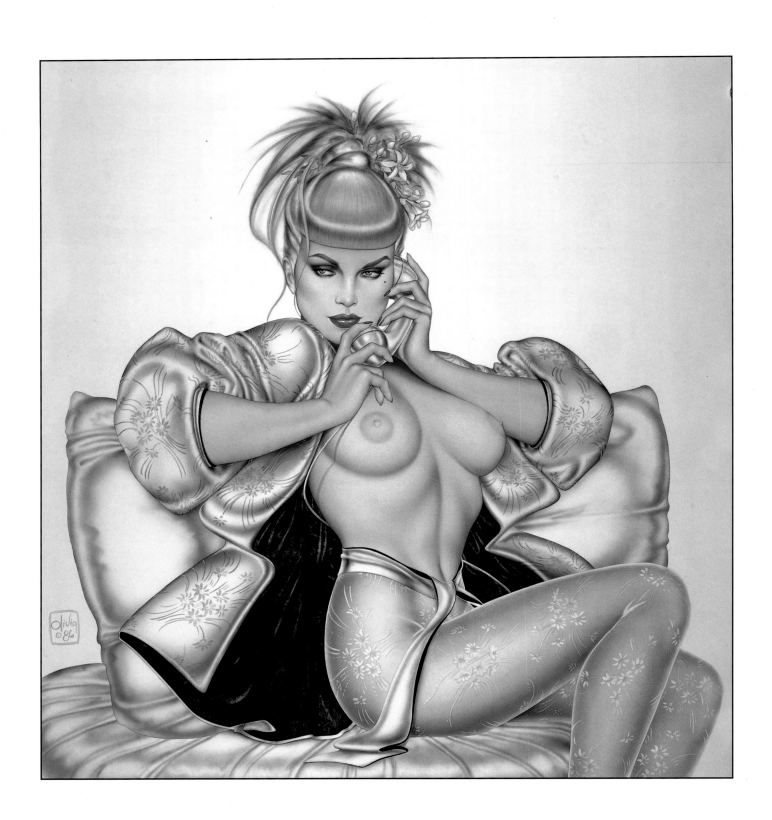

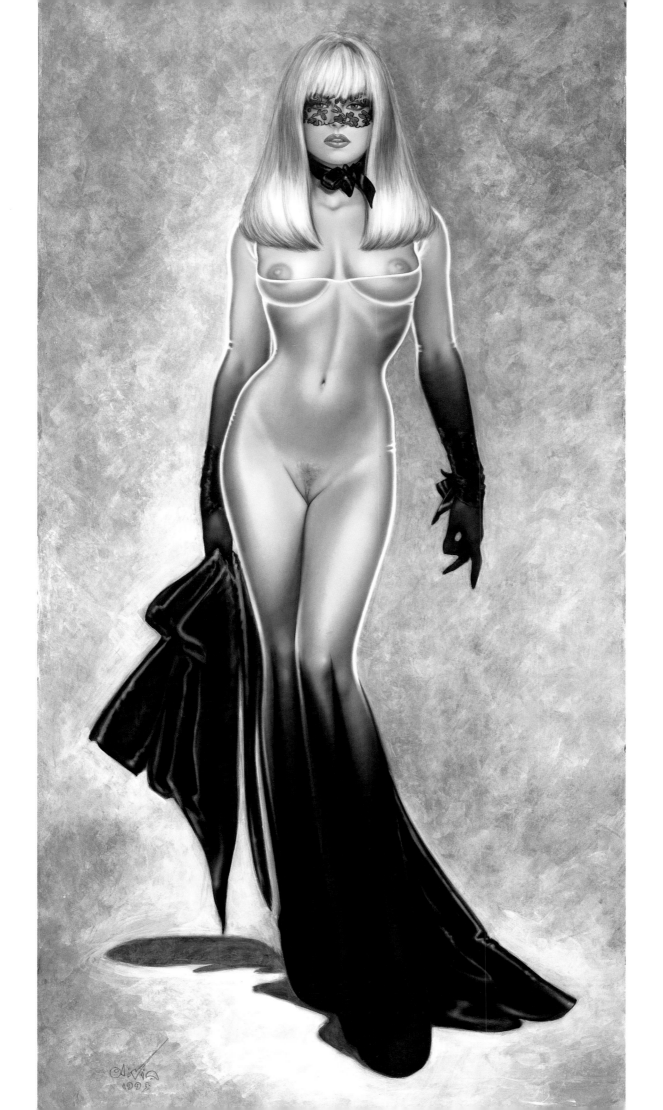

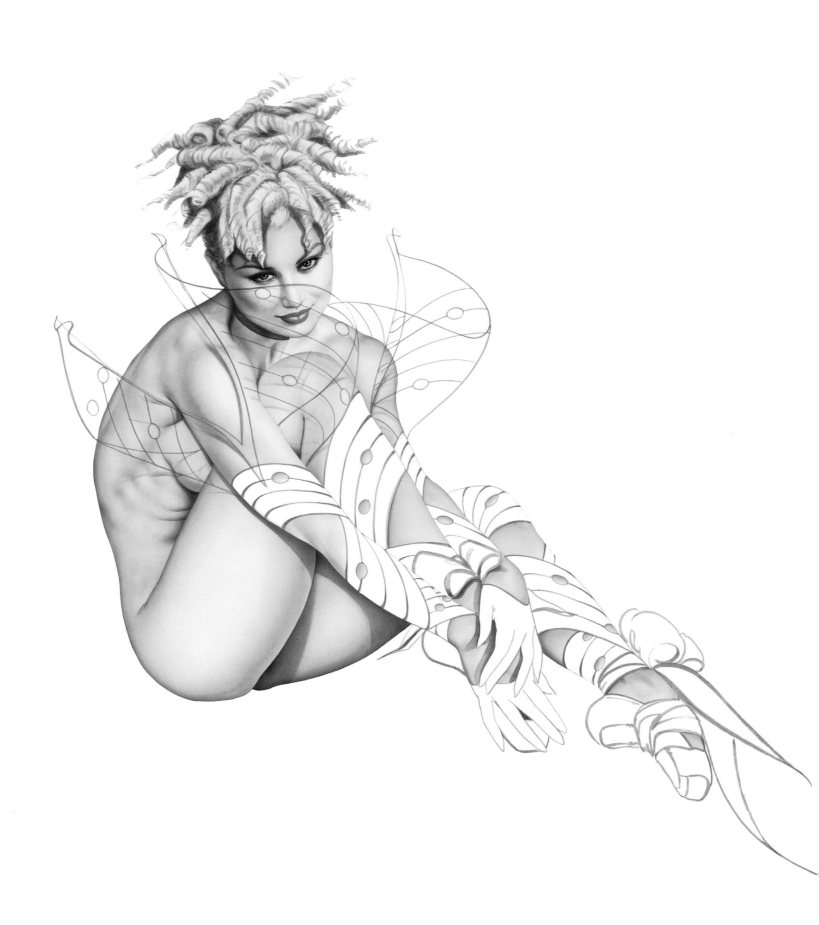

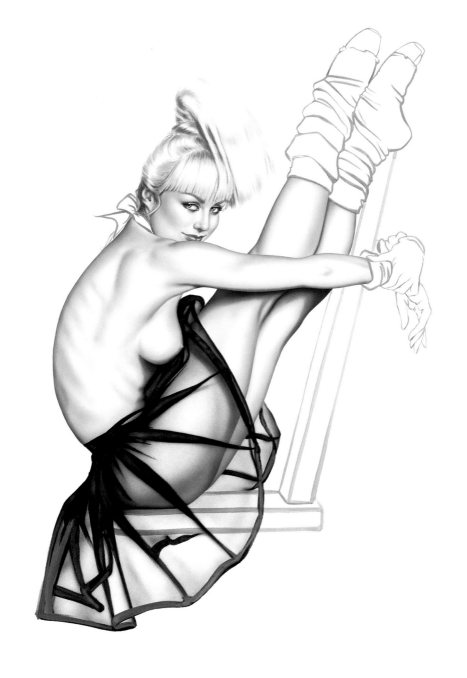

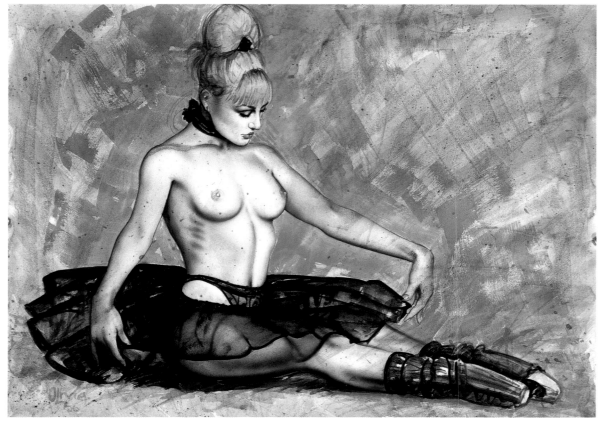

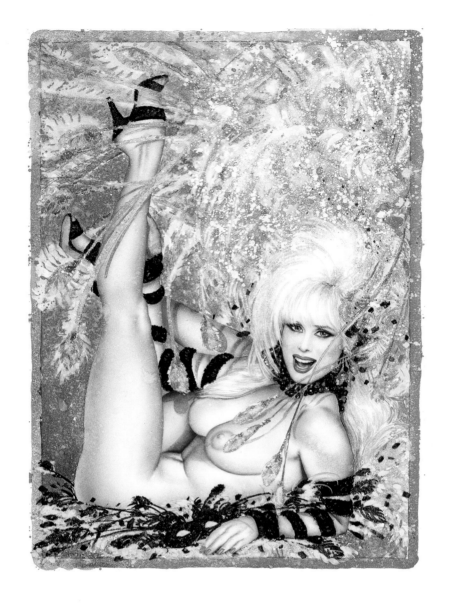

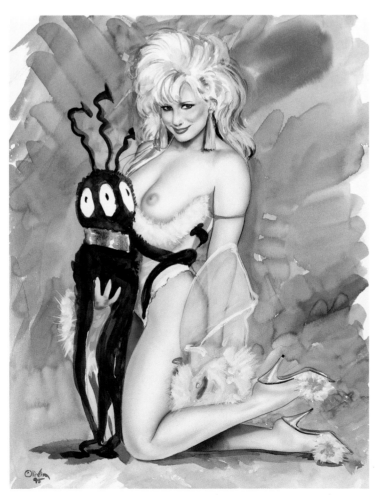

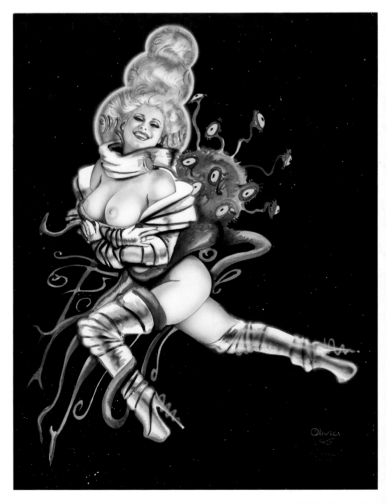

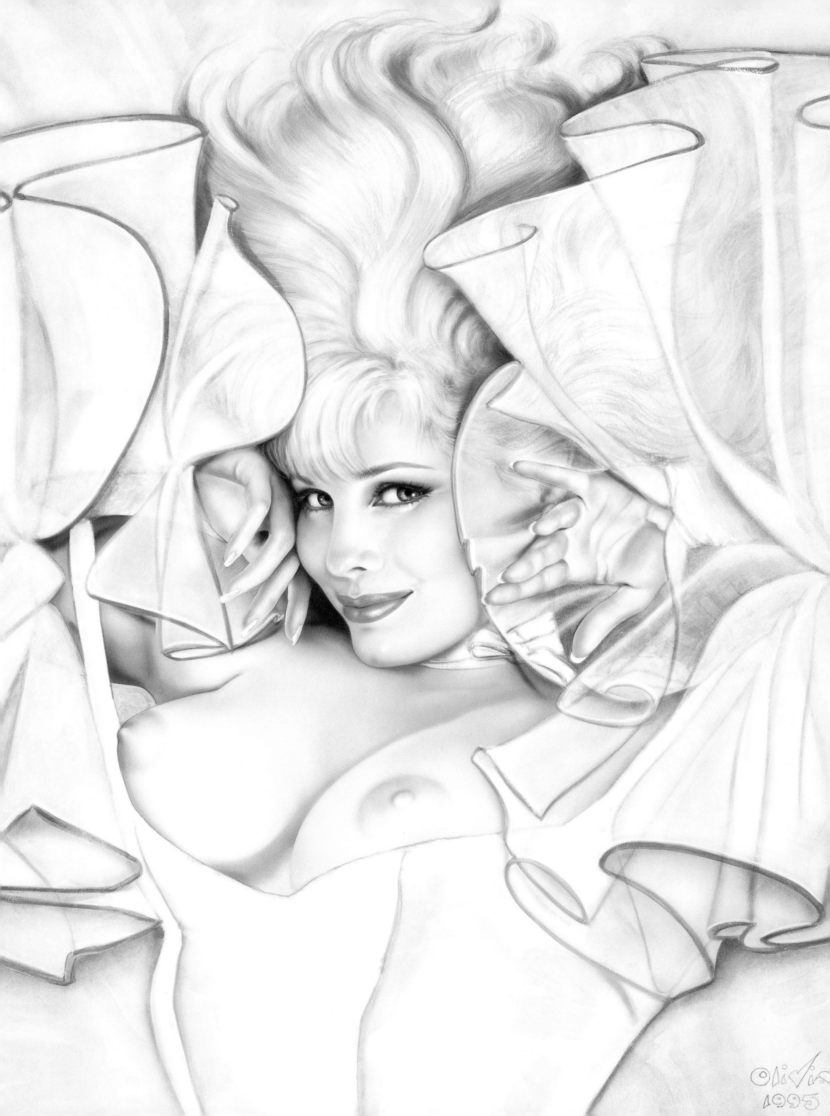

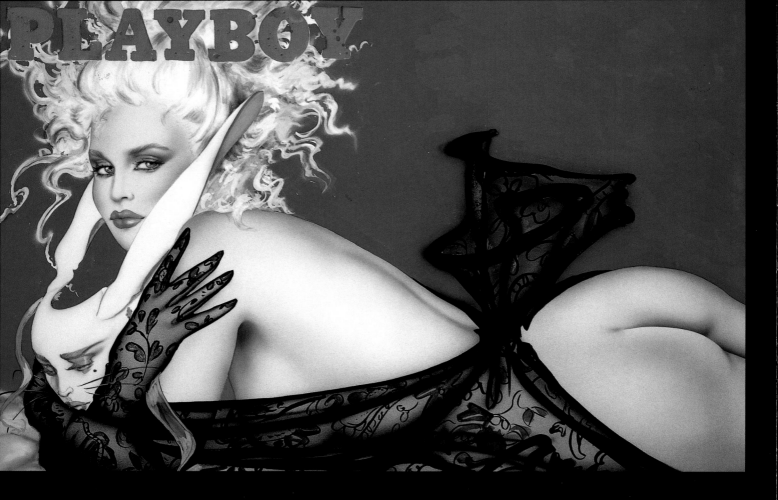

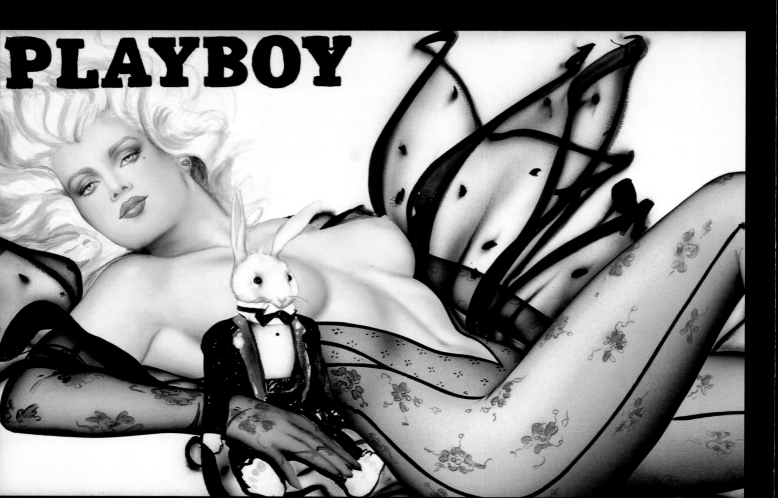

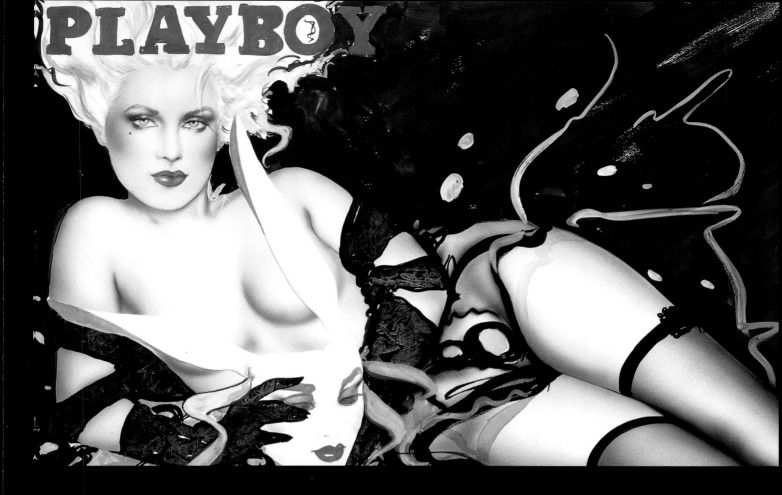

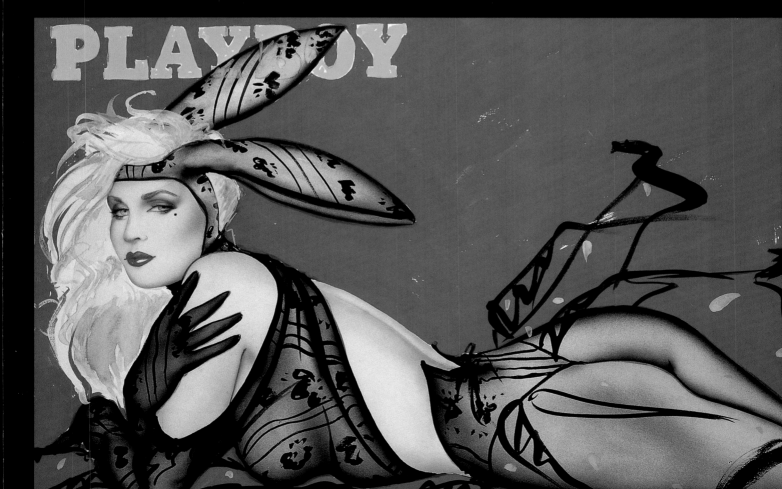

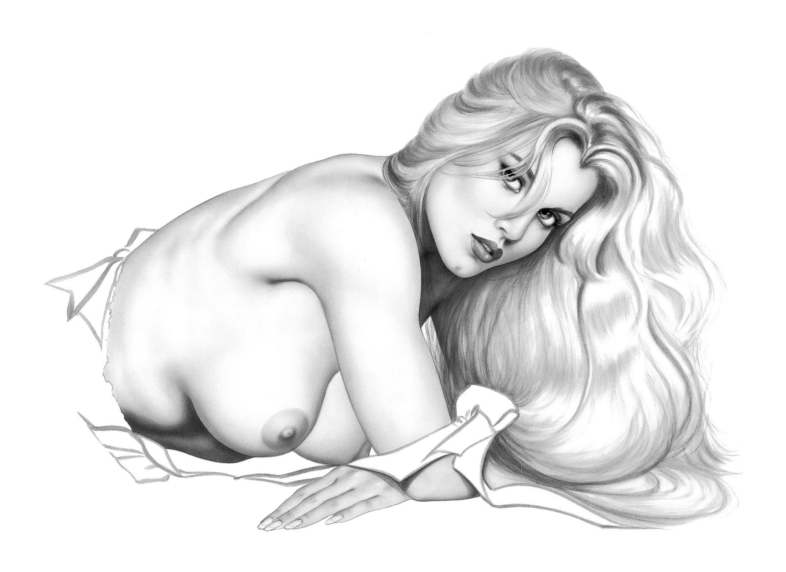
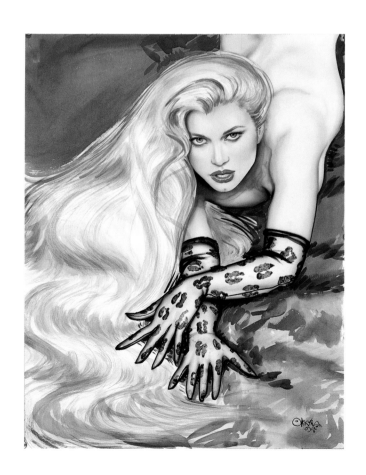

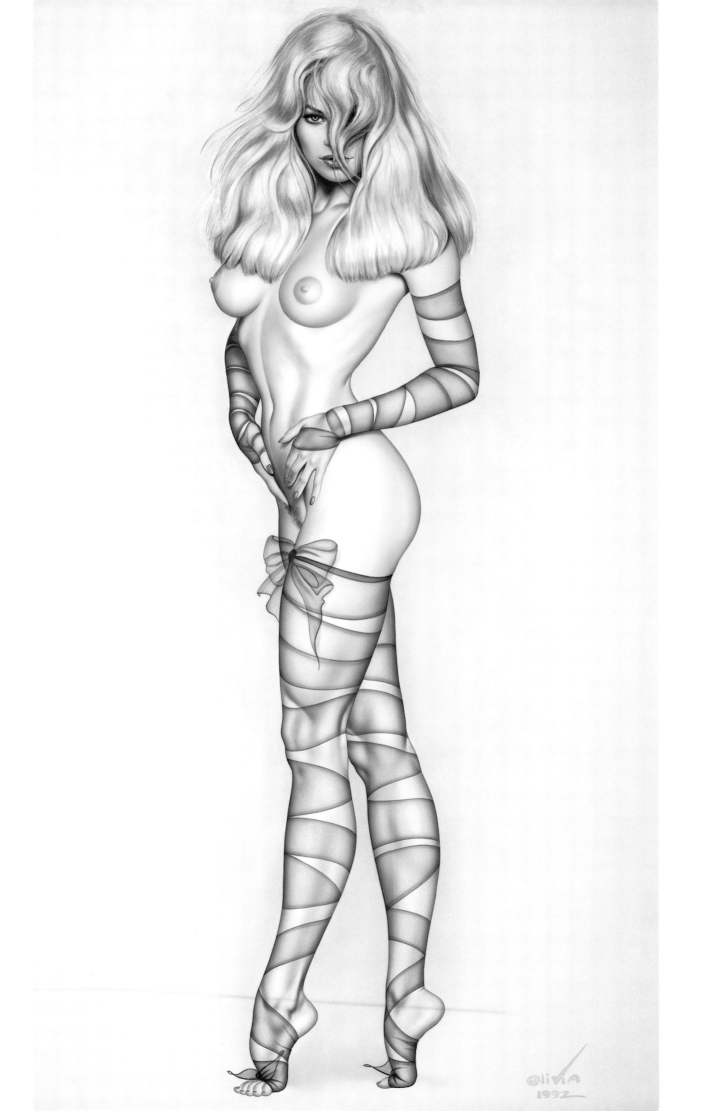

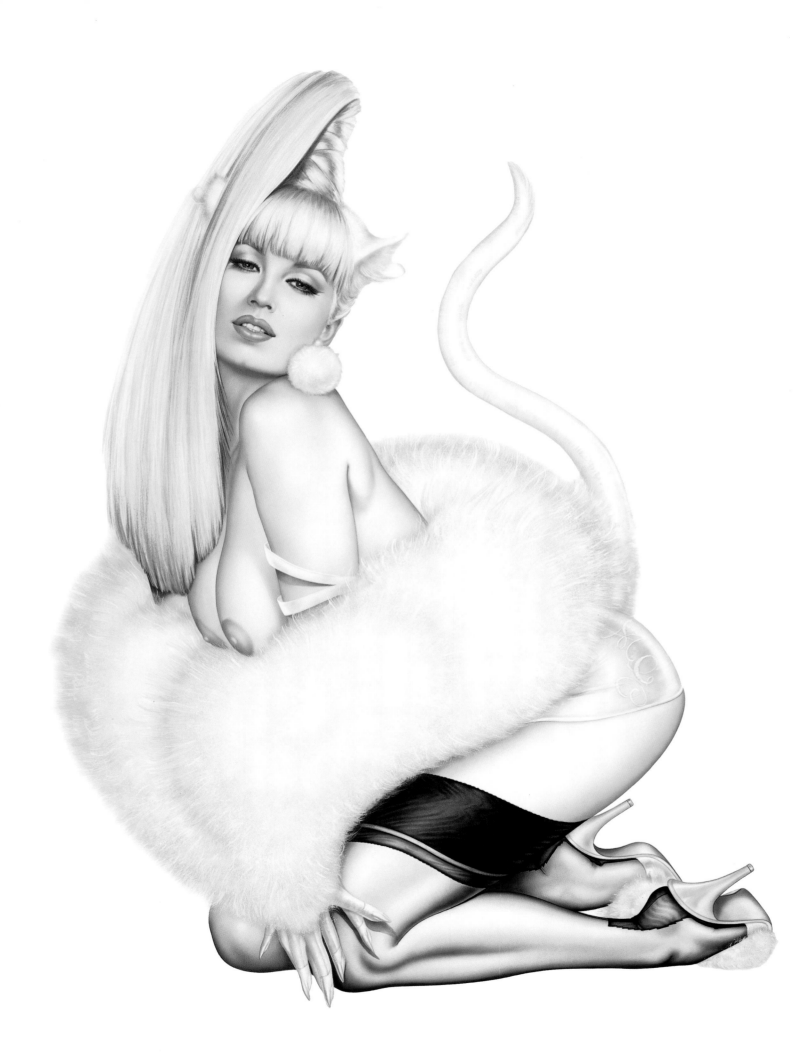

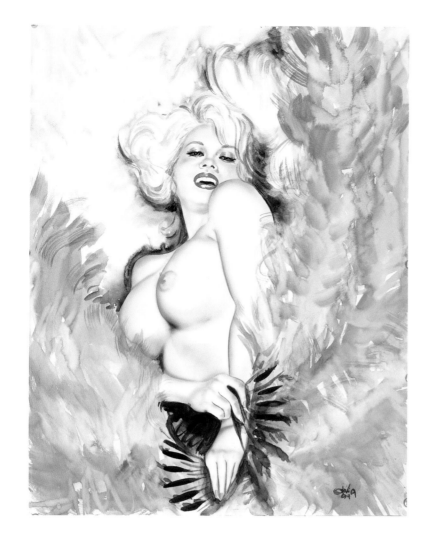

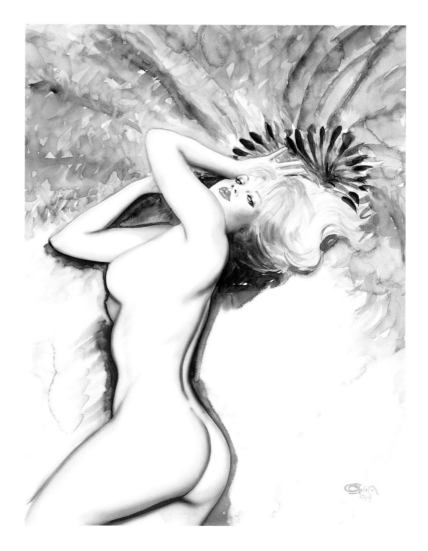

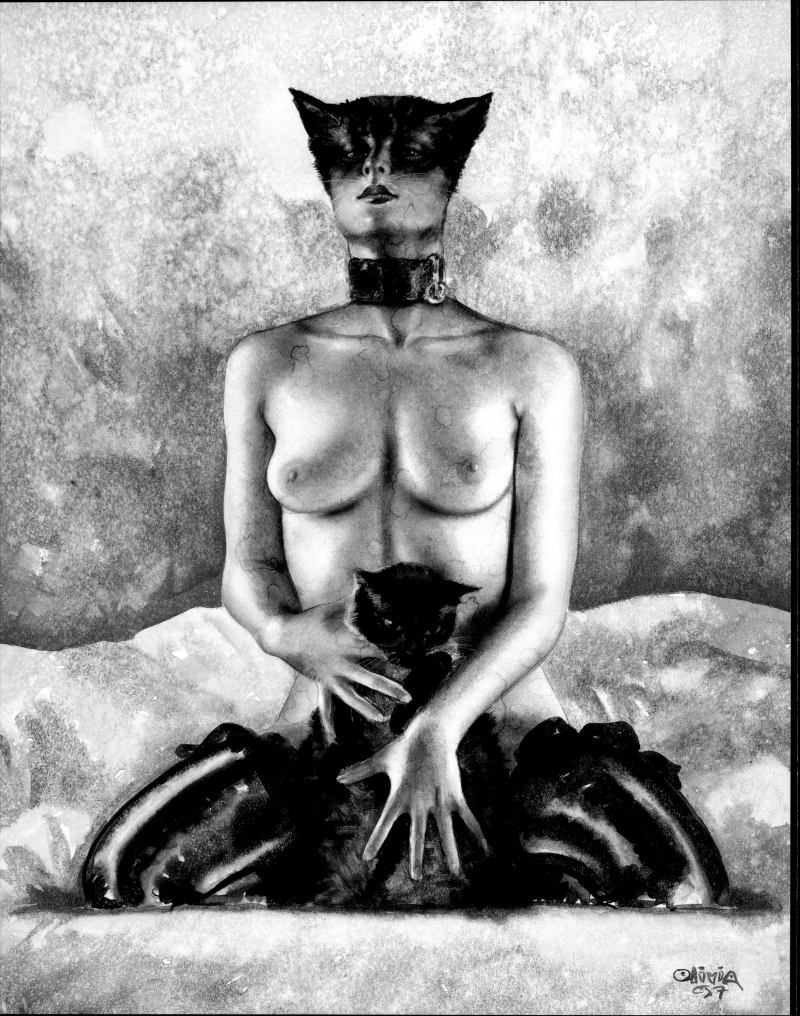

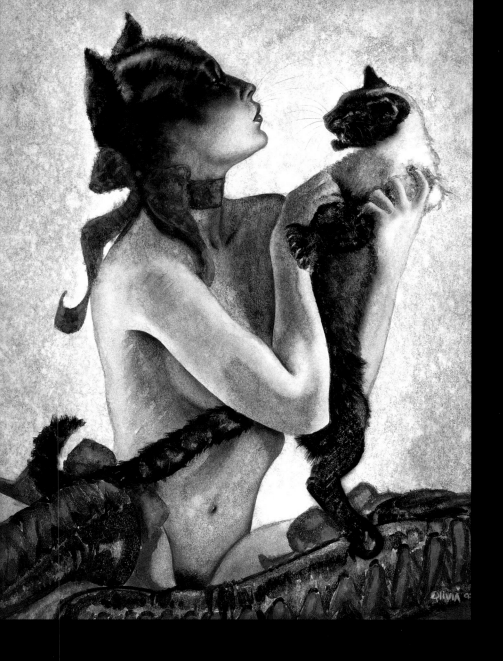
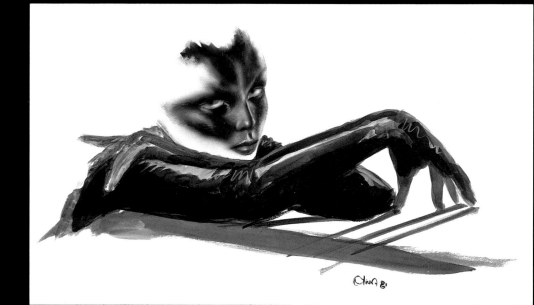

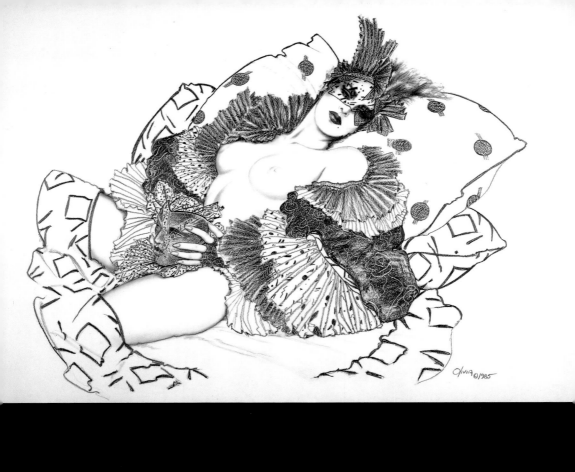

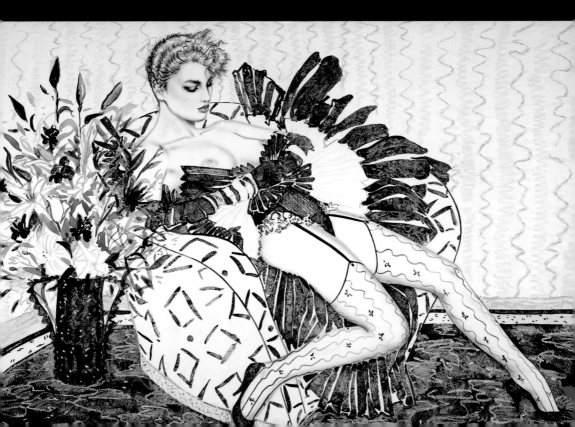

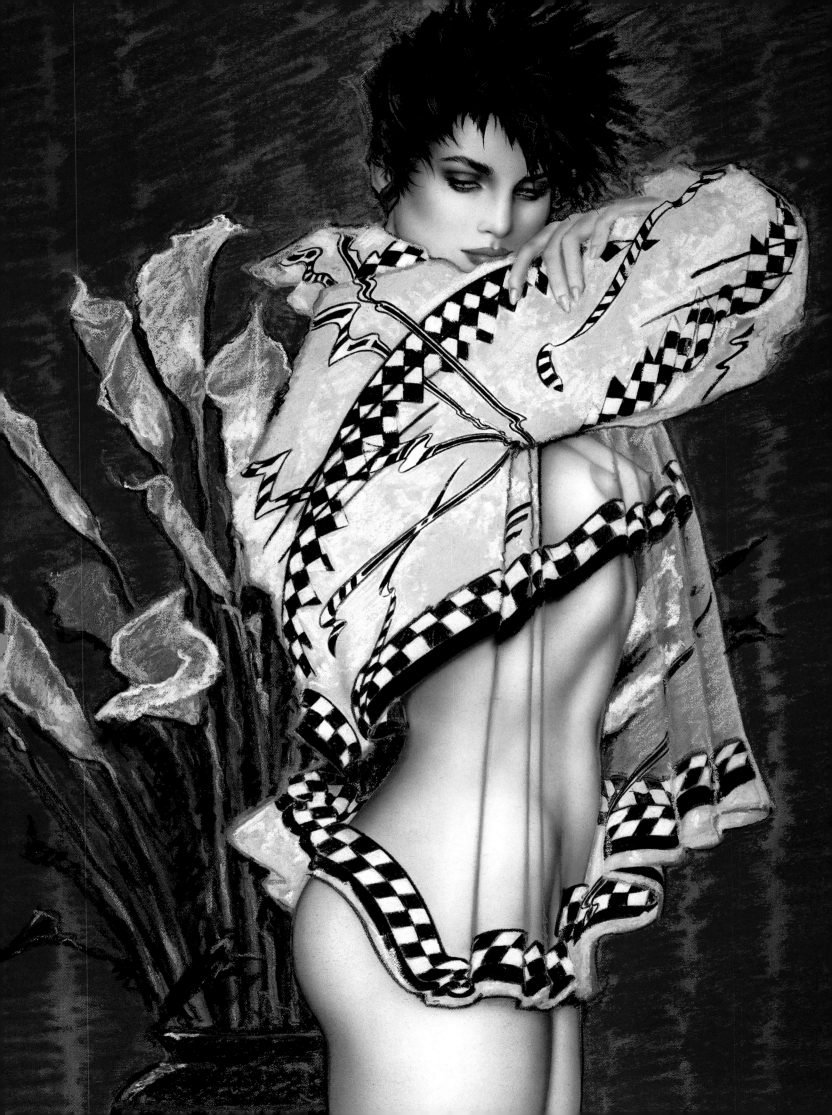

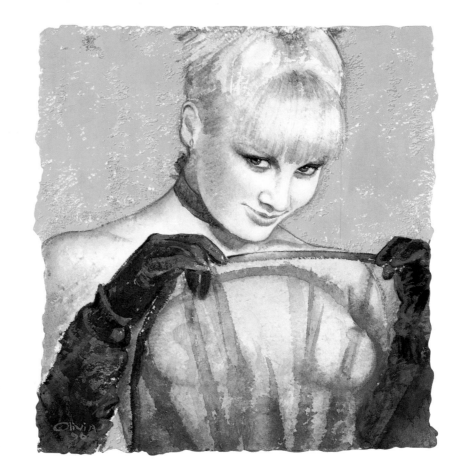

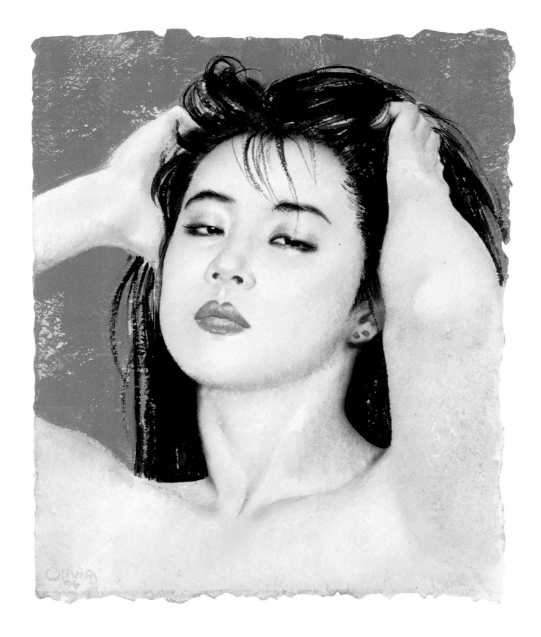

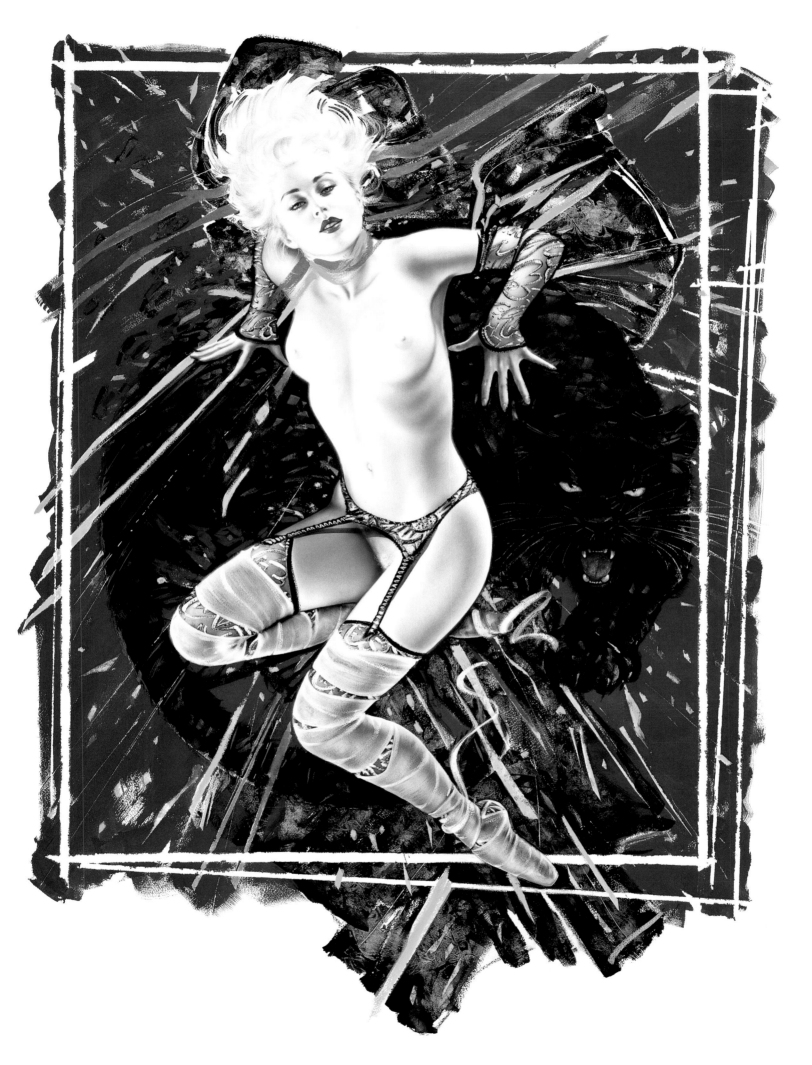

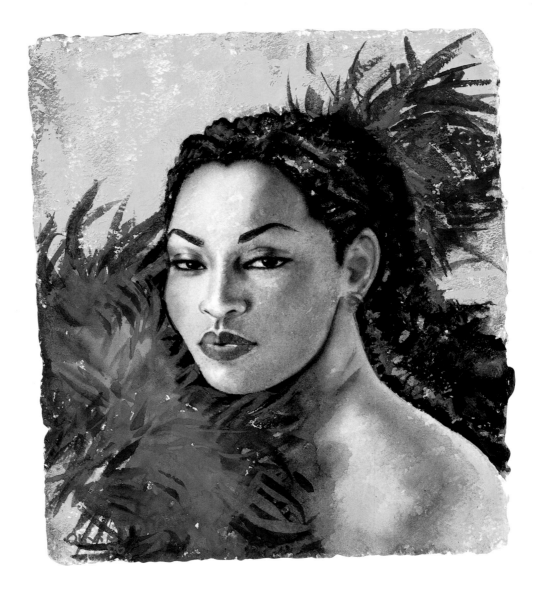

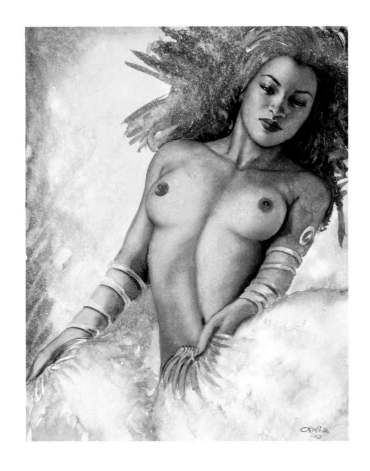

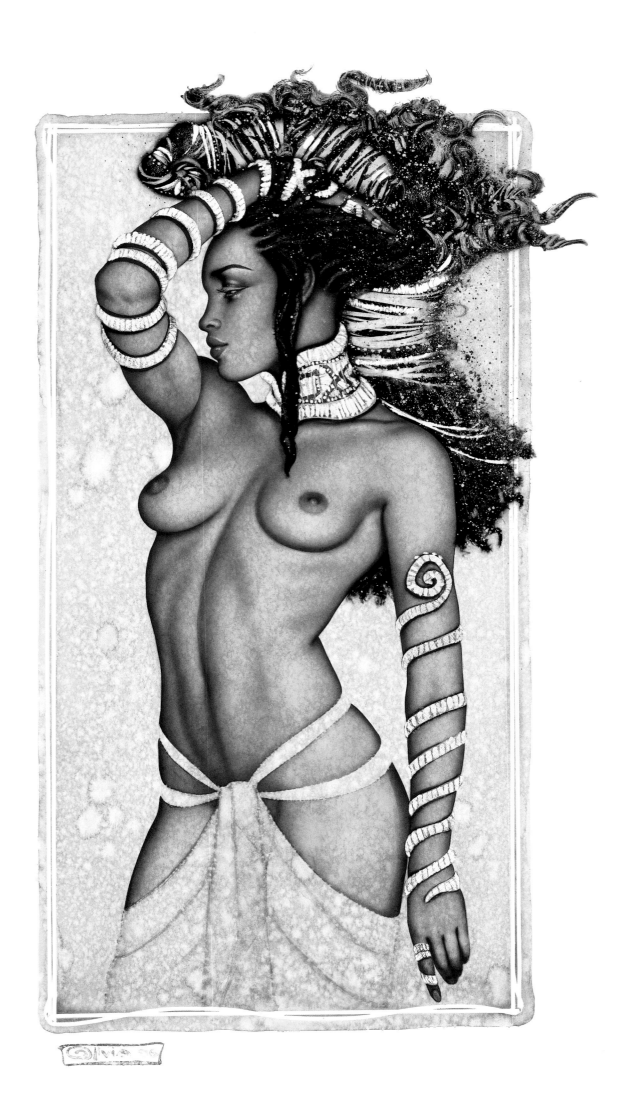

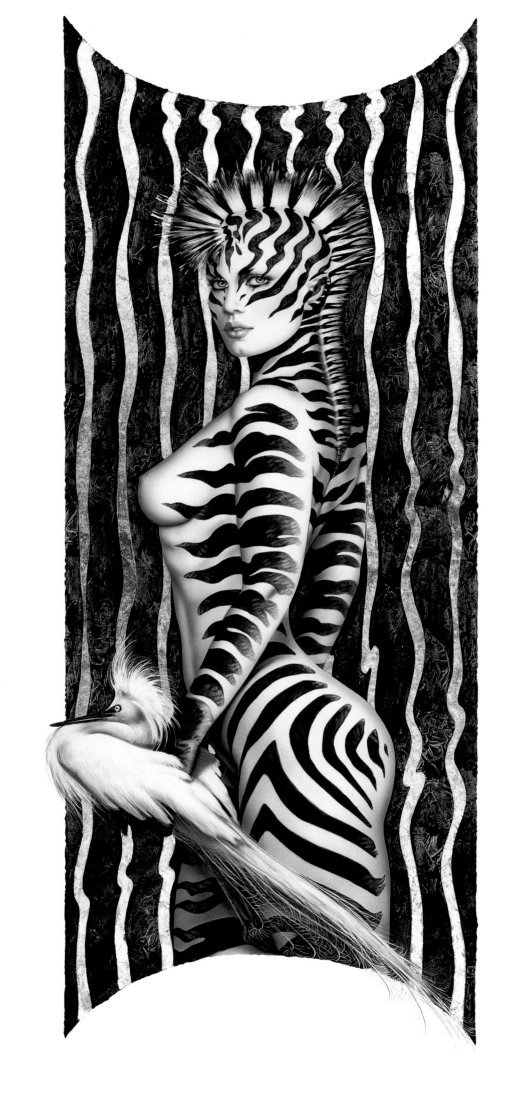

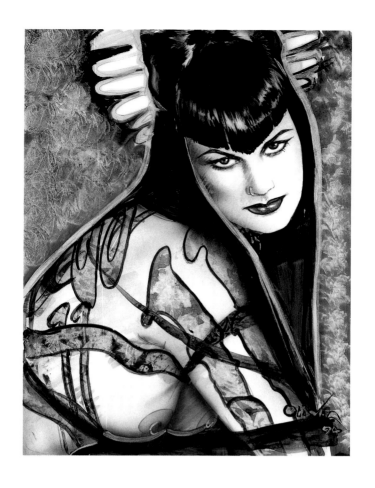

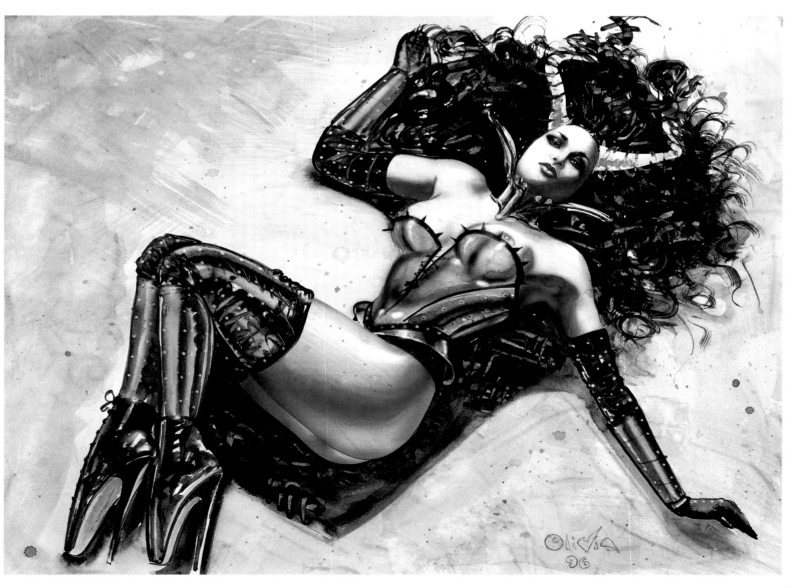

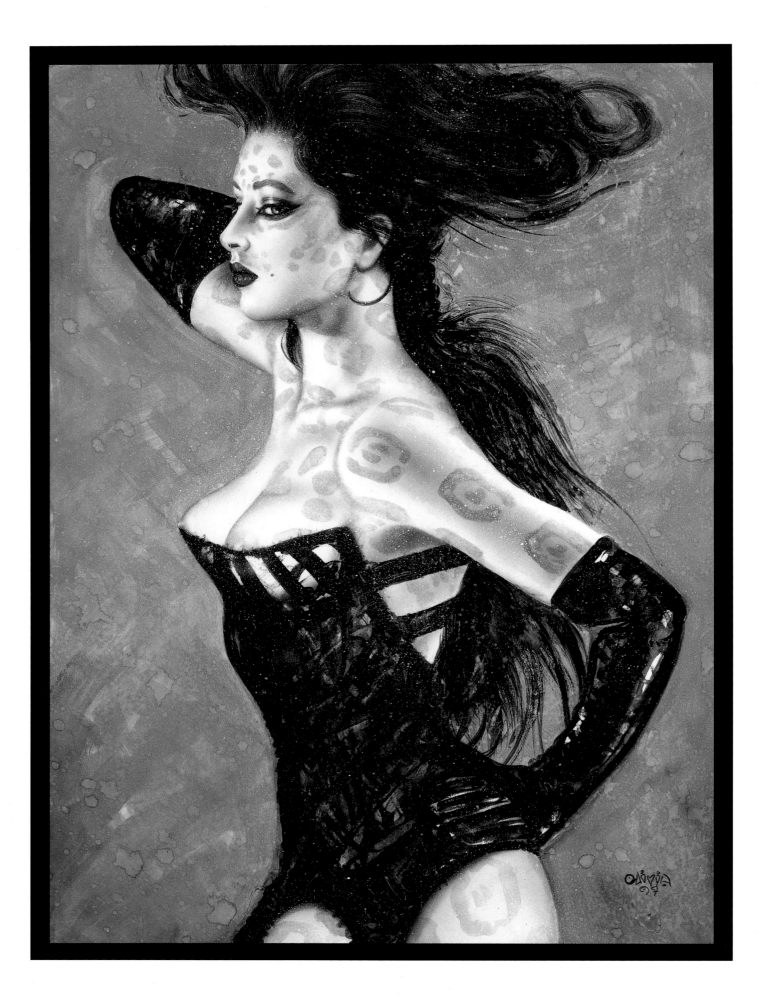

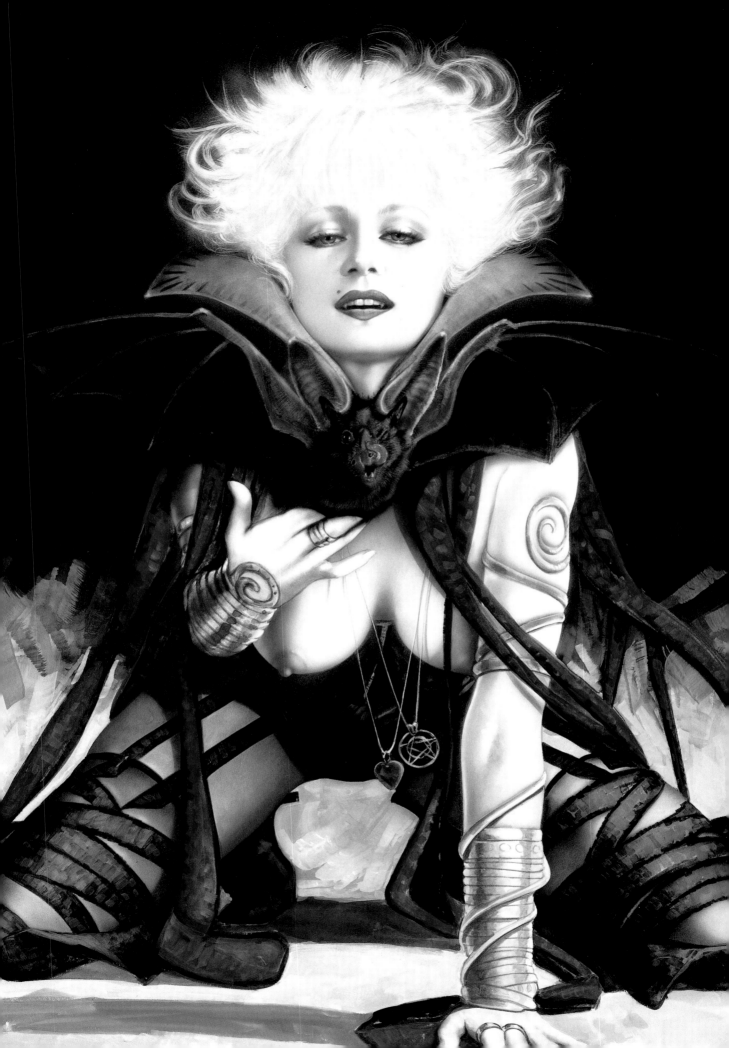

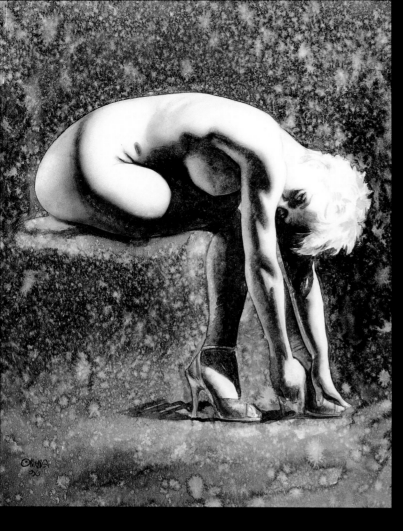

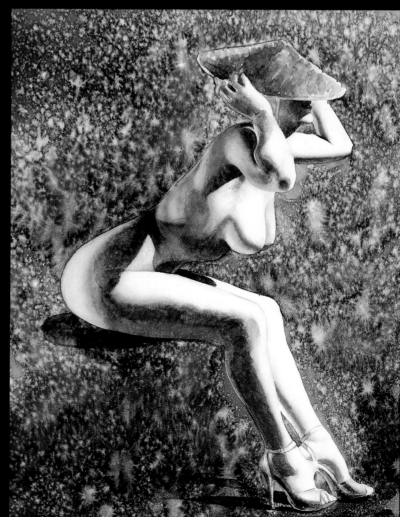

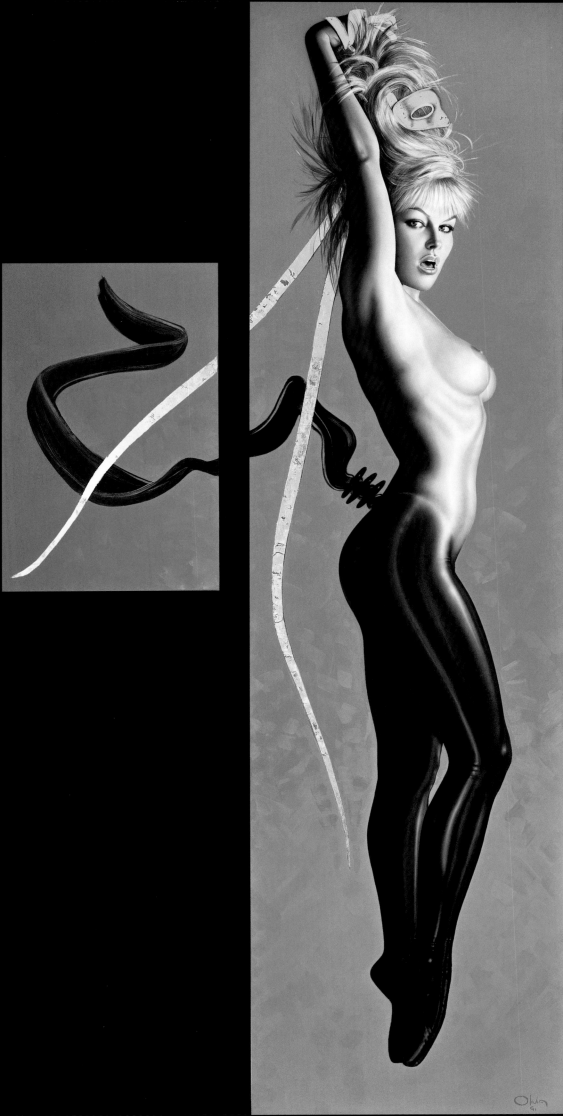

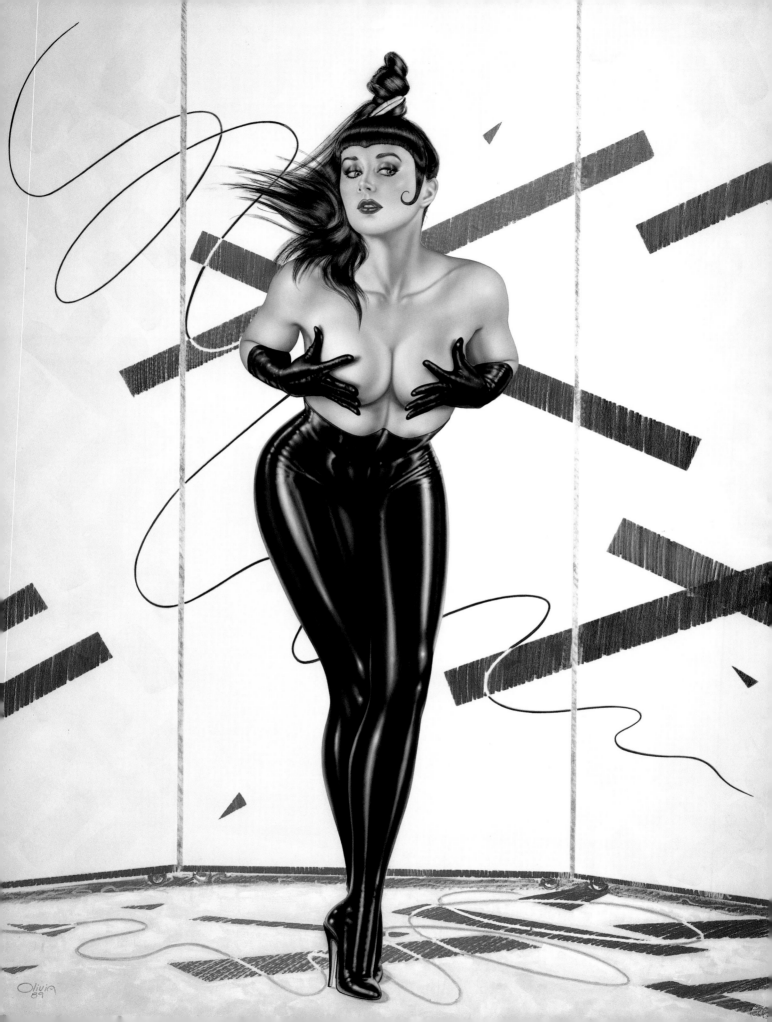

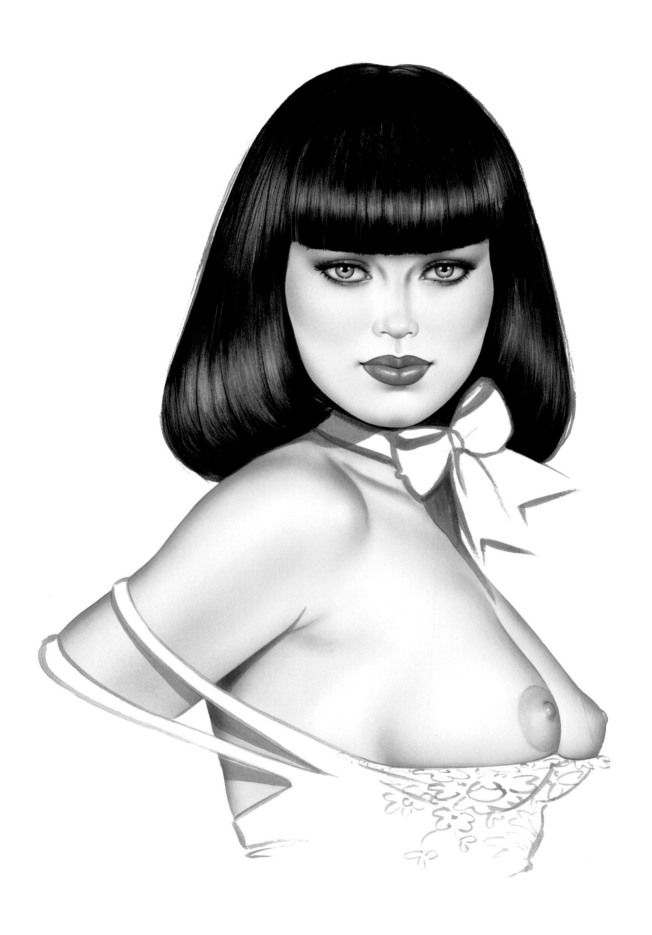

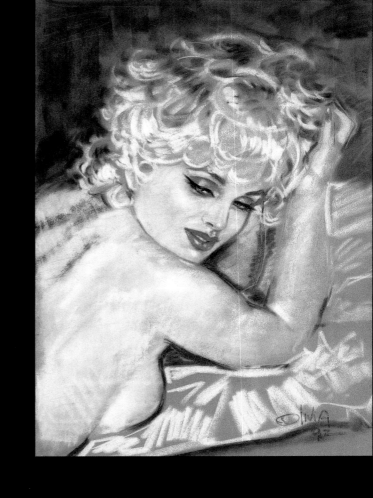

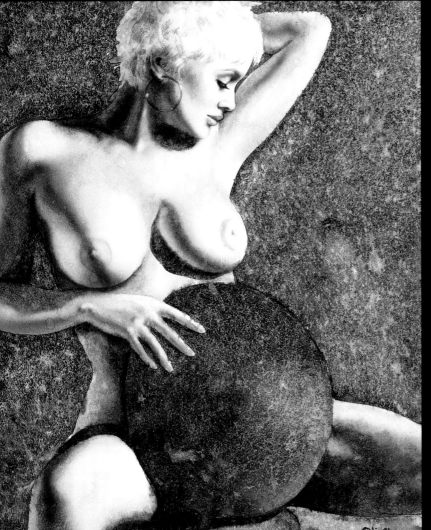

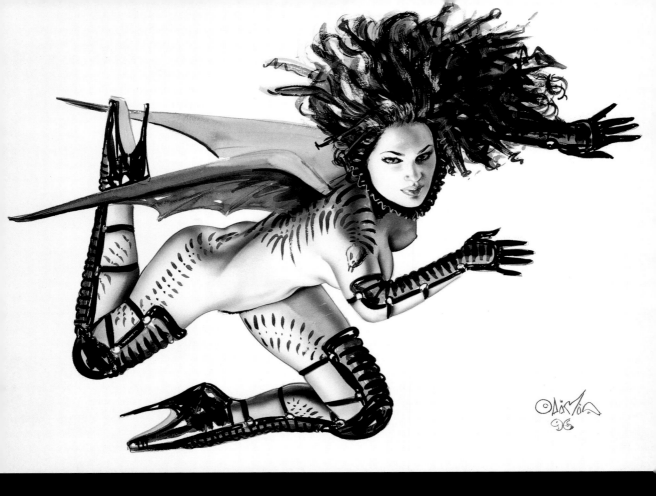

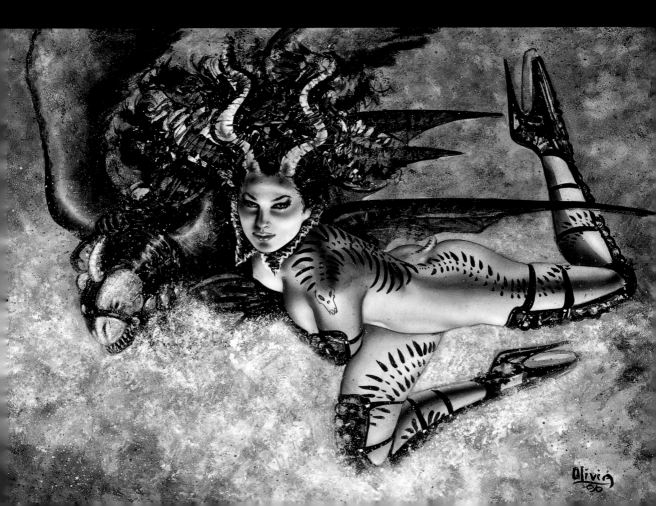

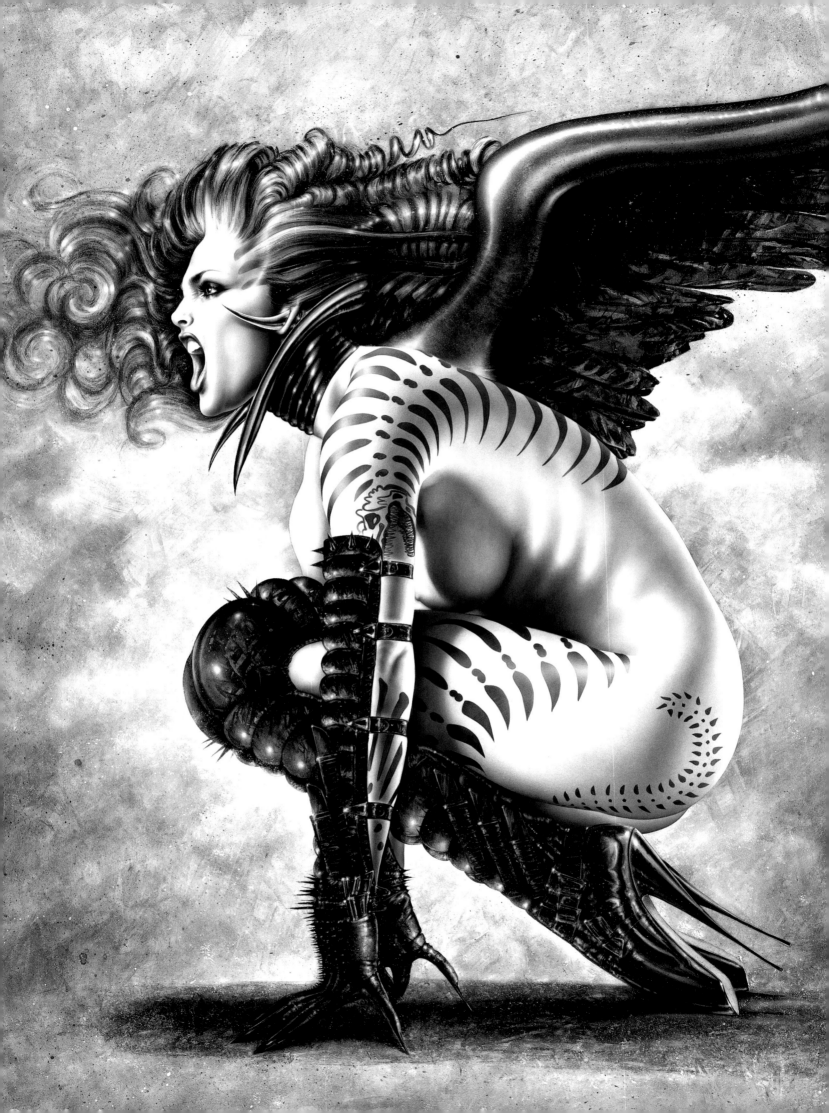

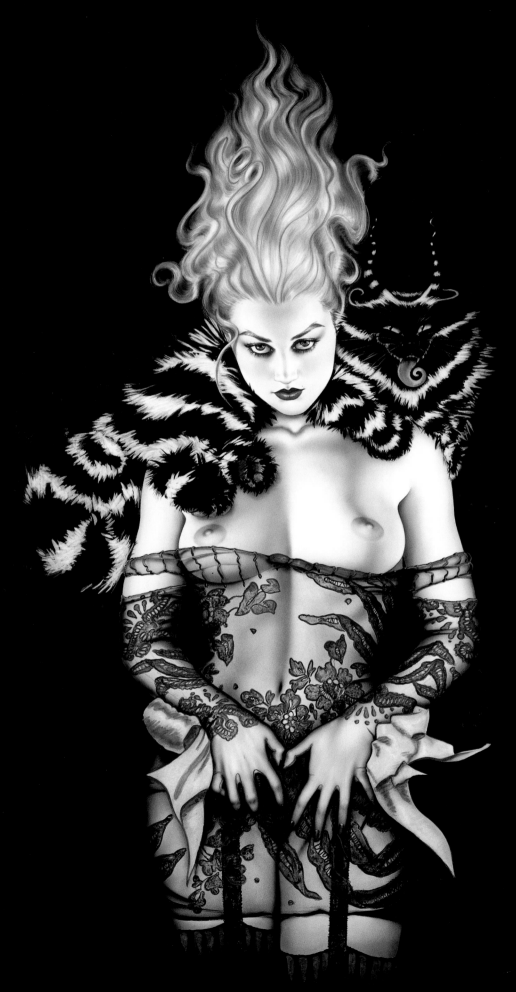

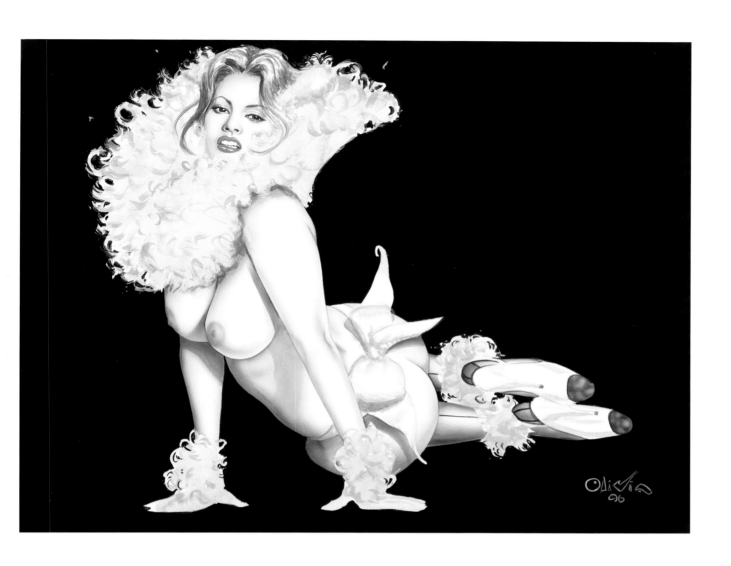

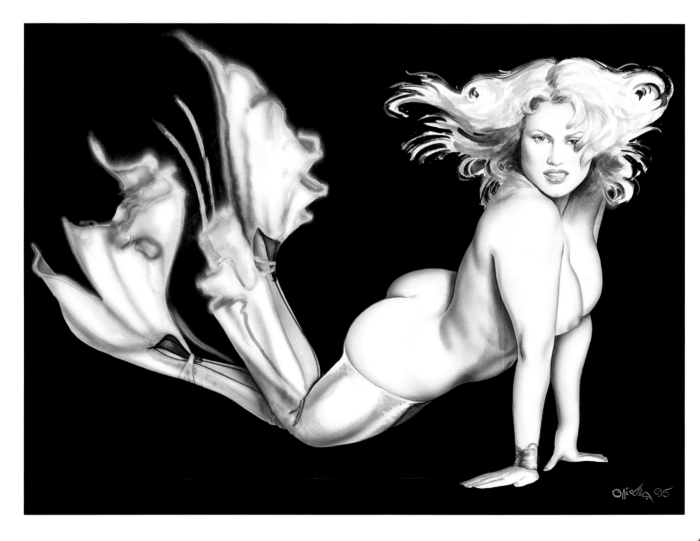

49

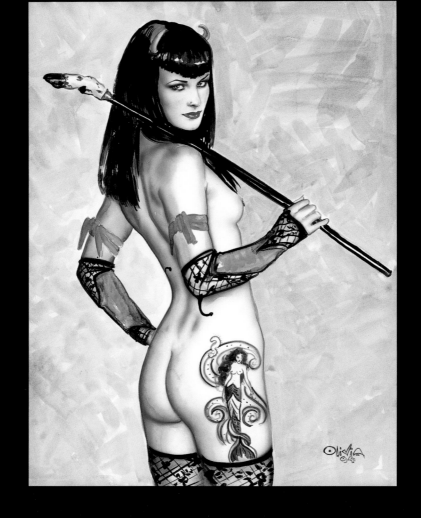

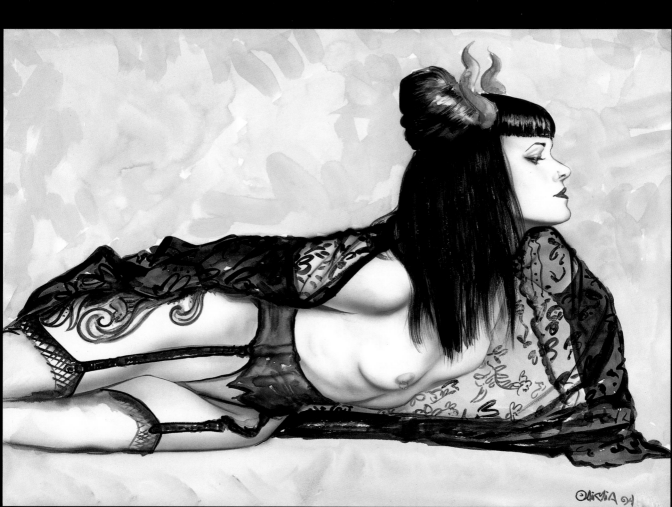

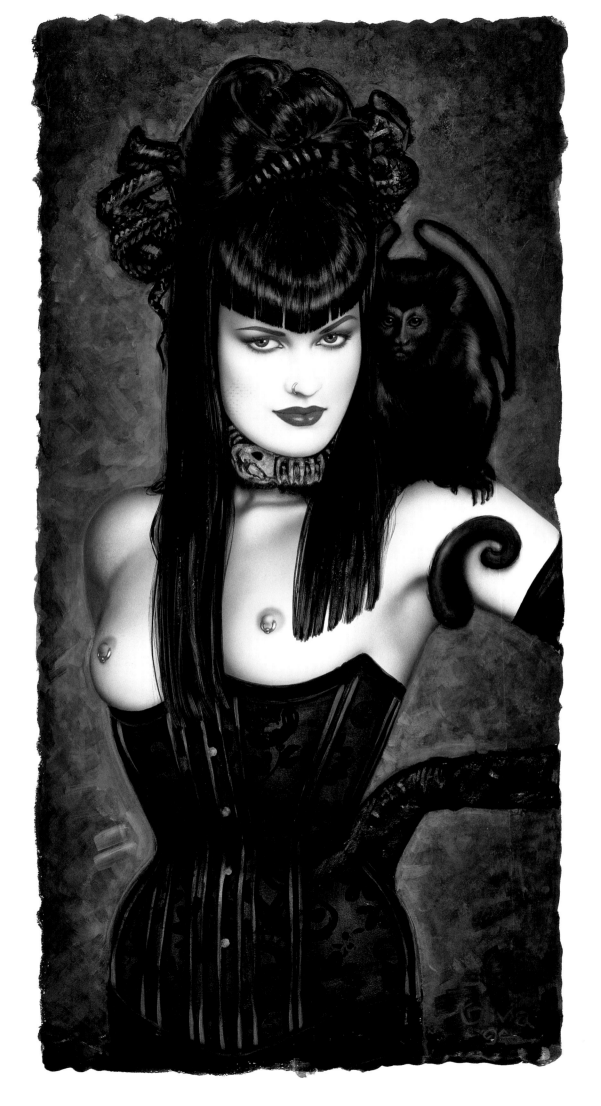

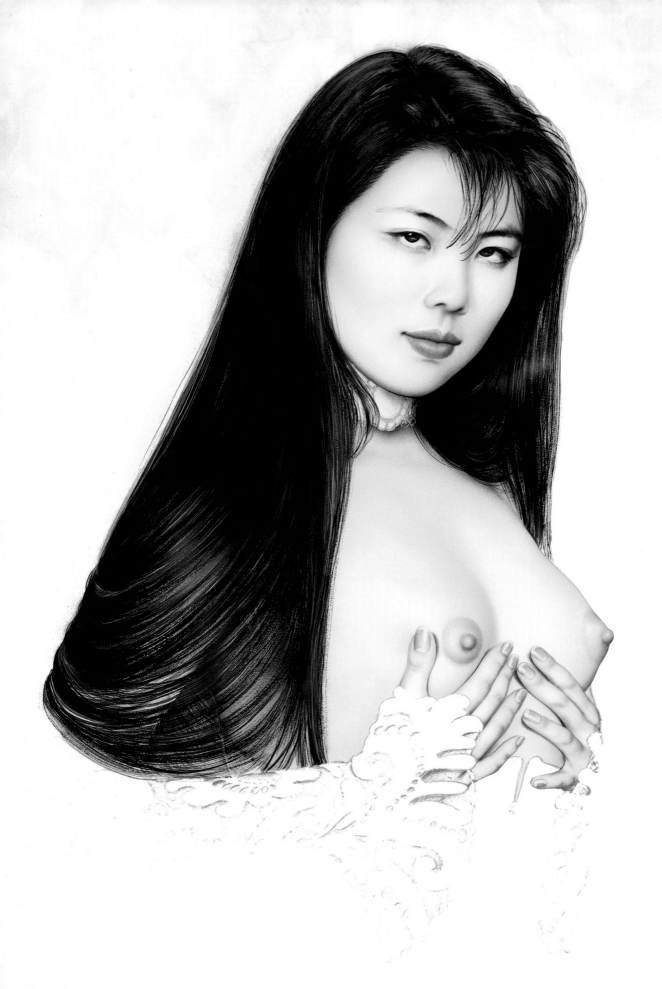

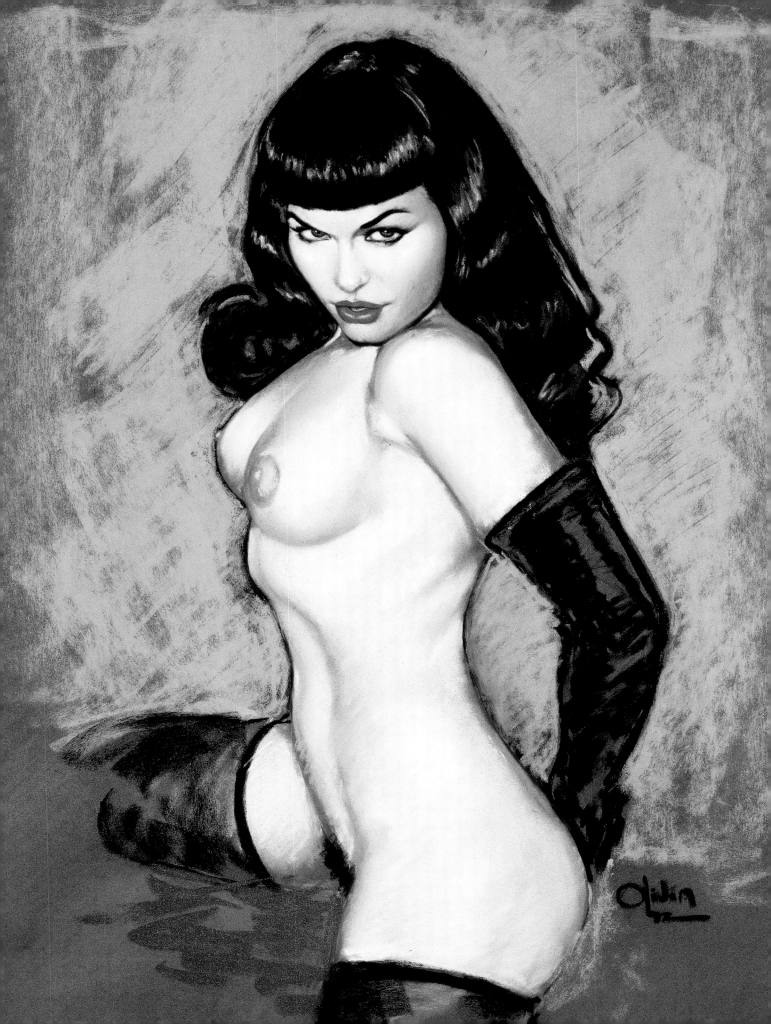

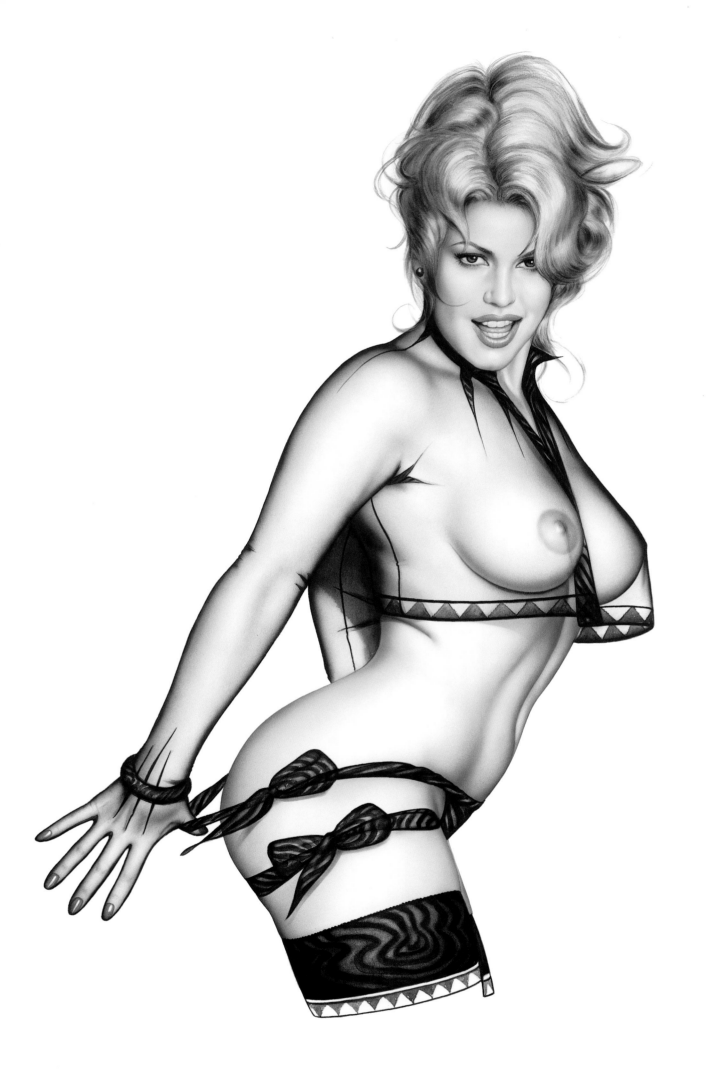

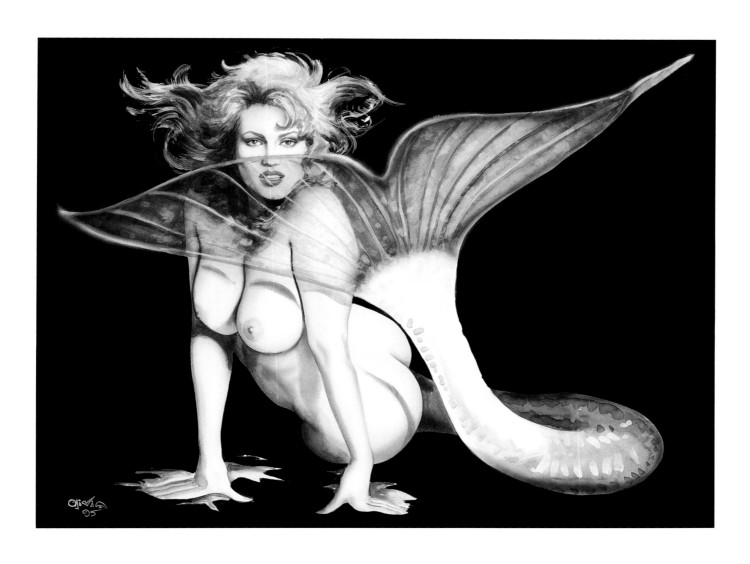

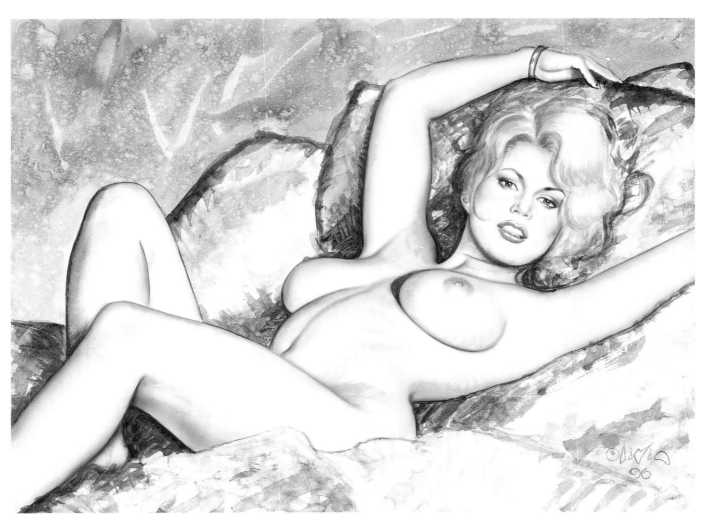

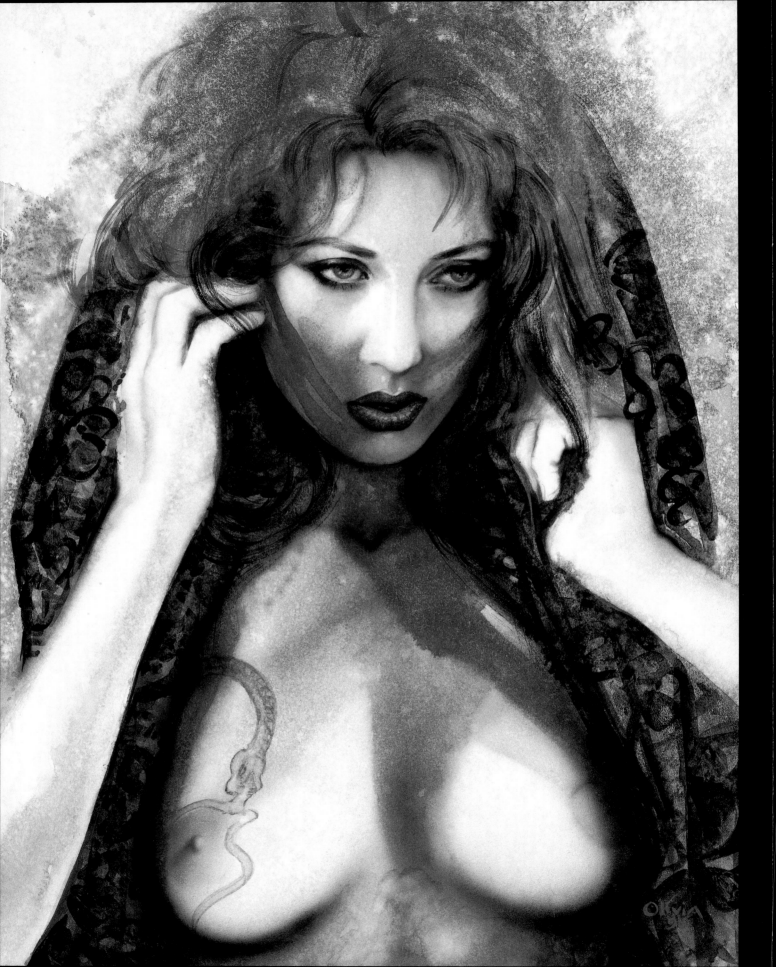

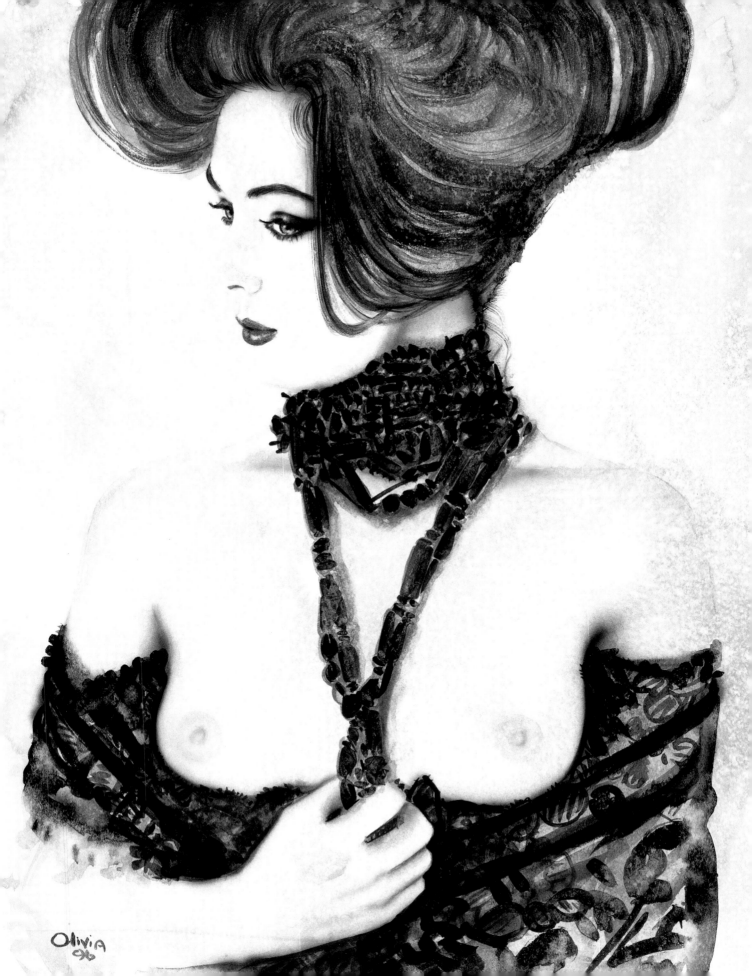

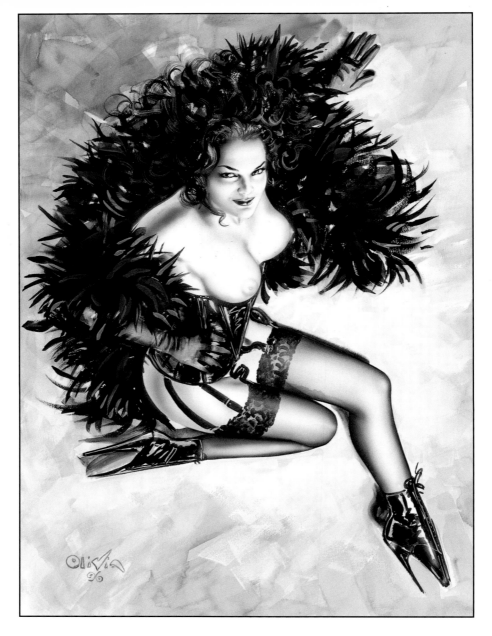

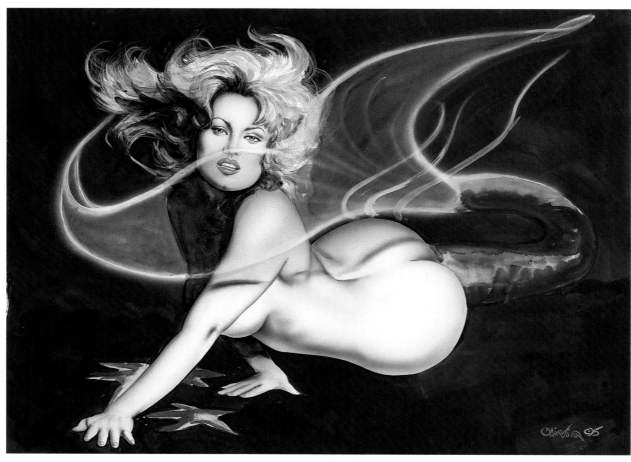

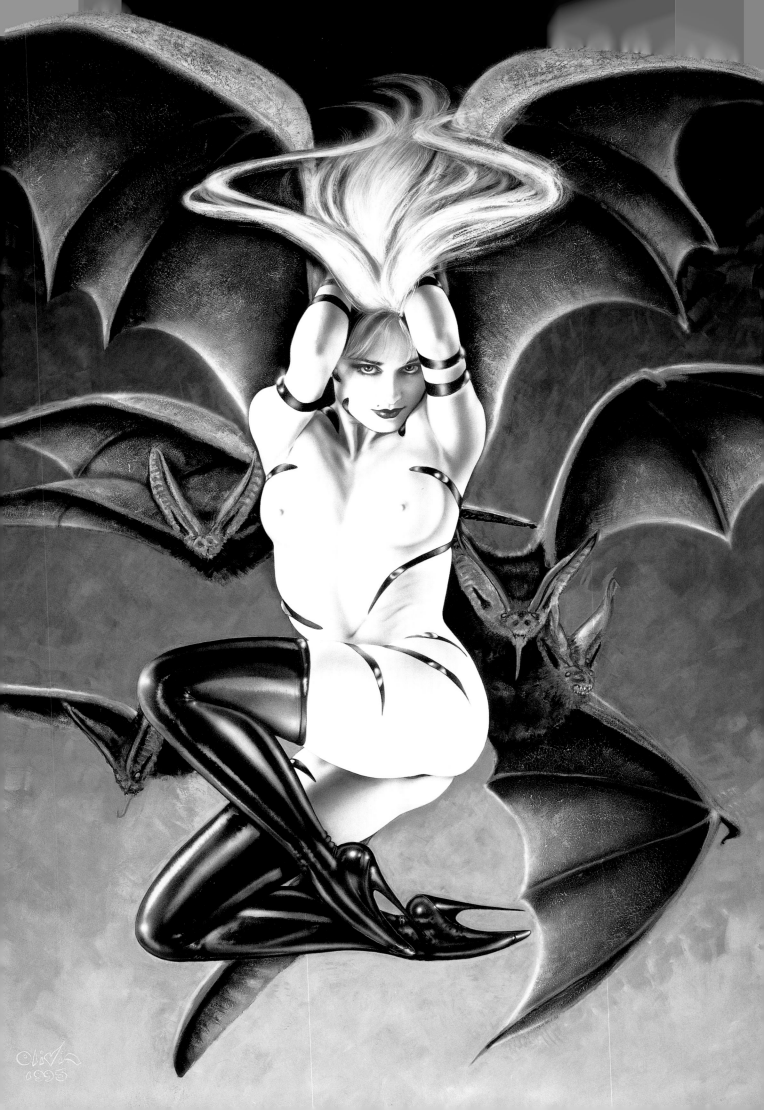

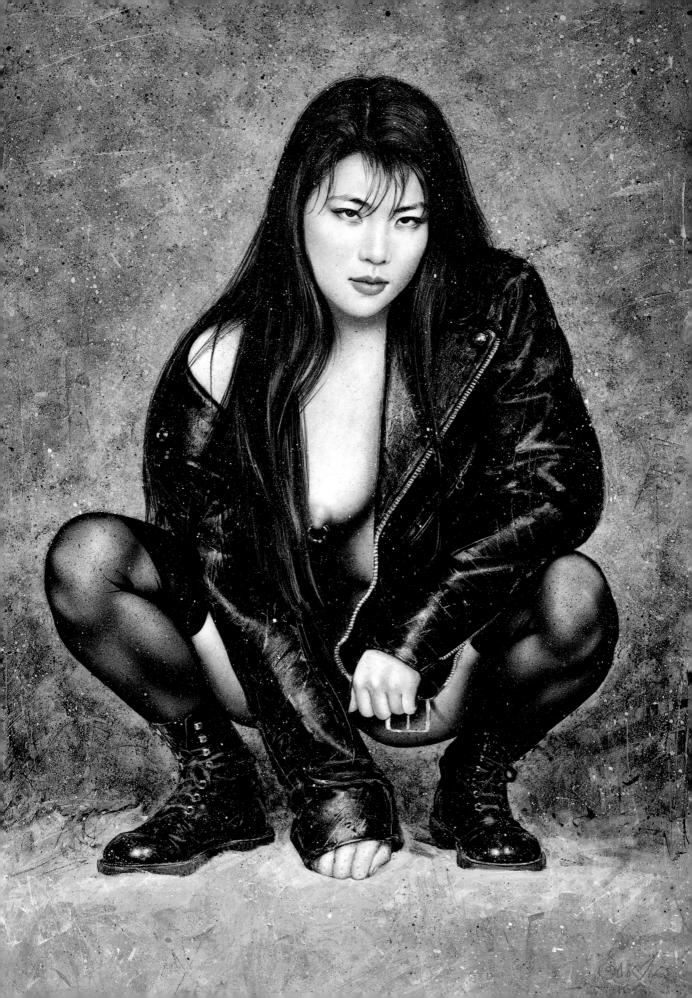

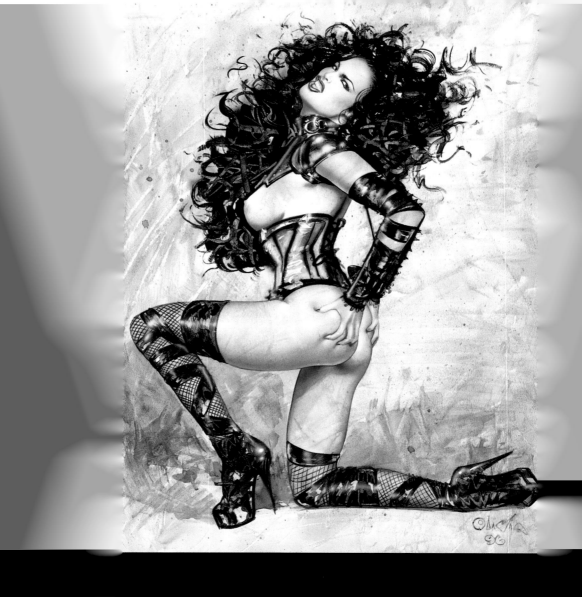
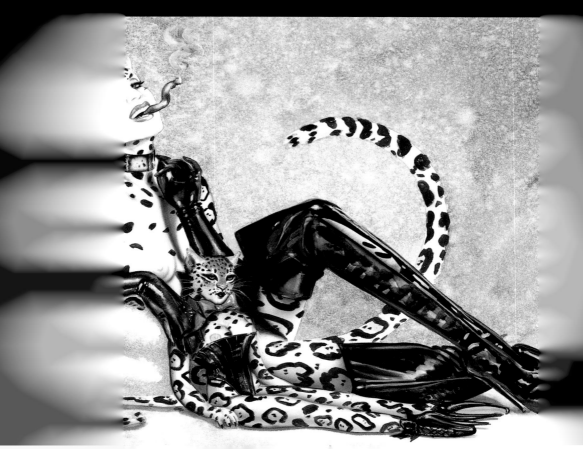

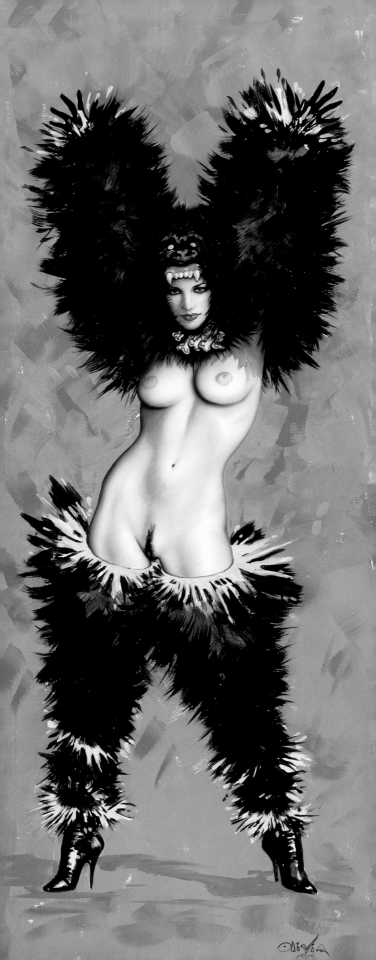

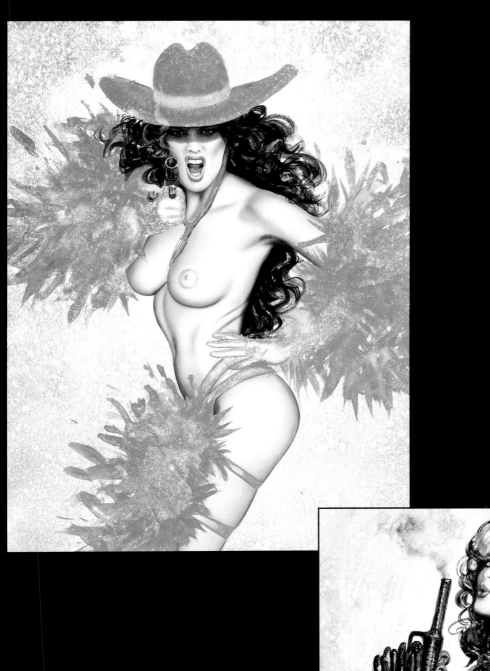
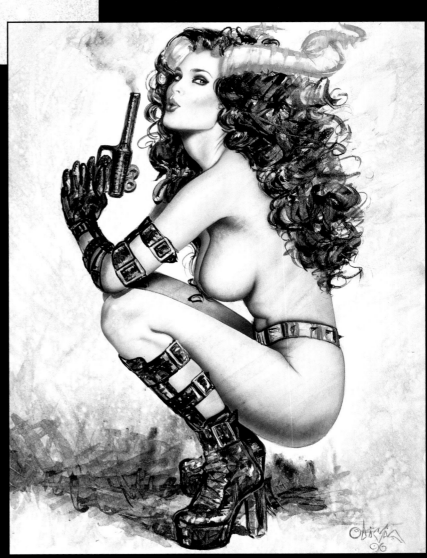

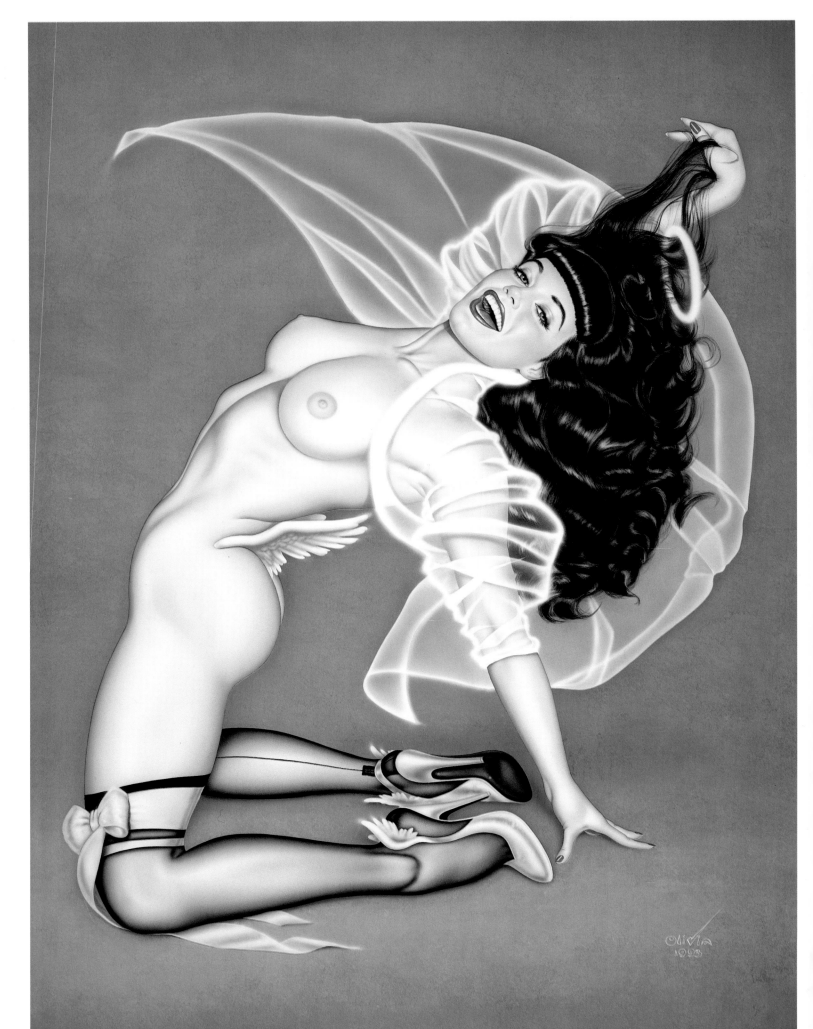

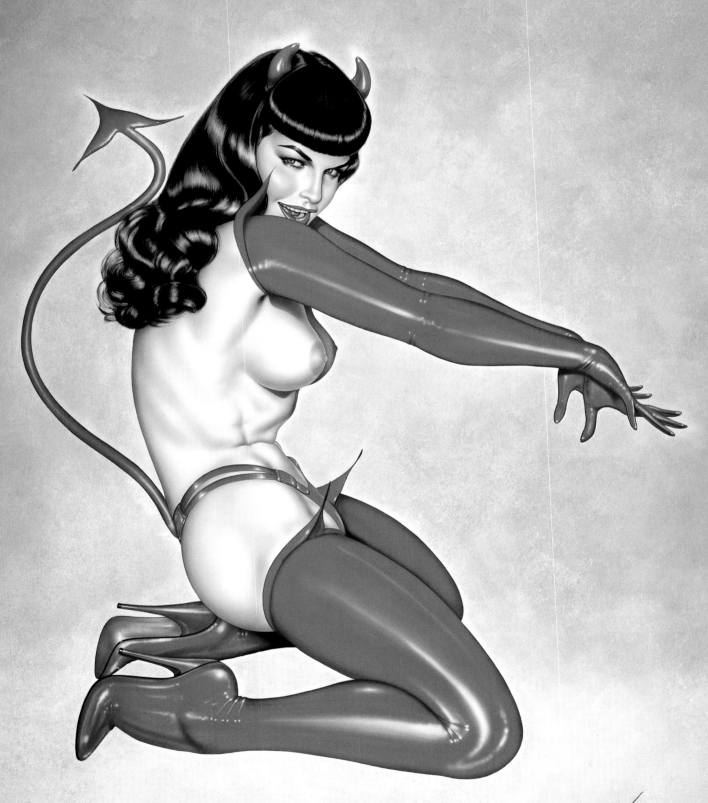

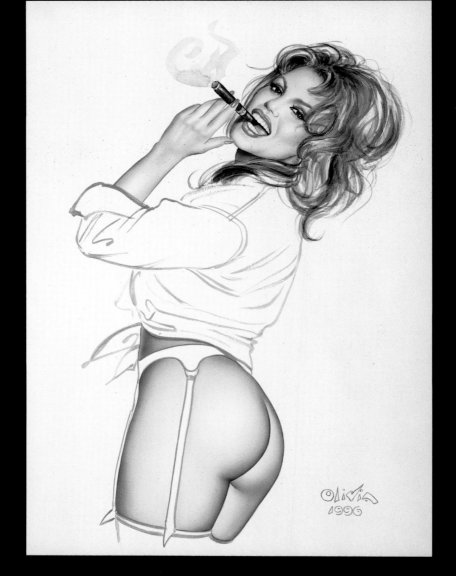

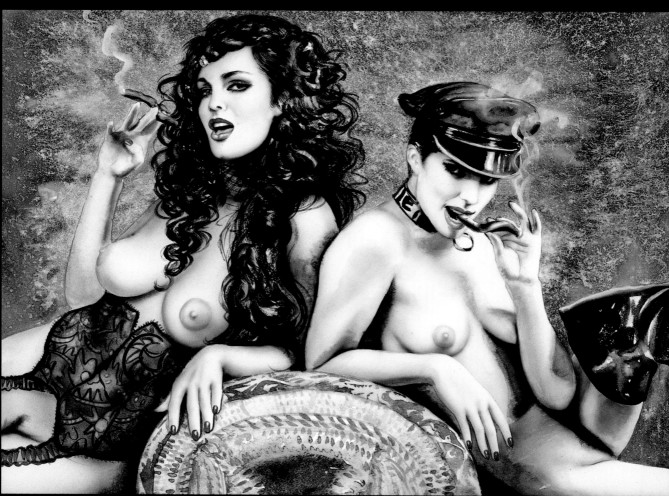

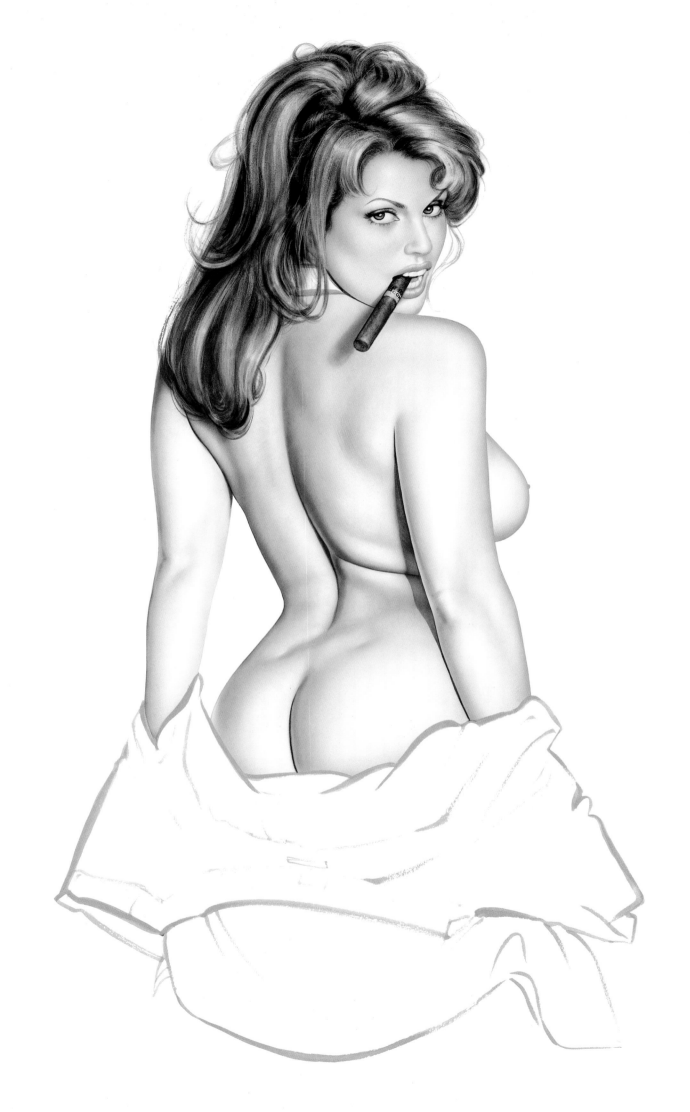

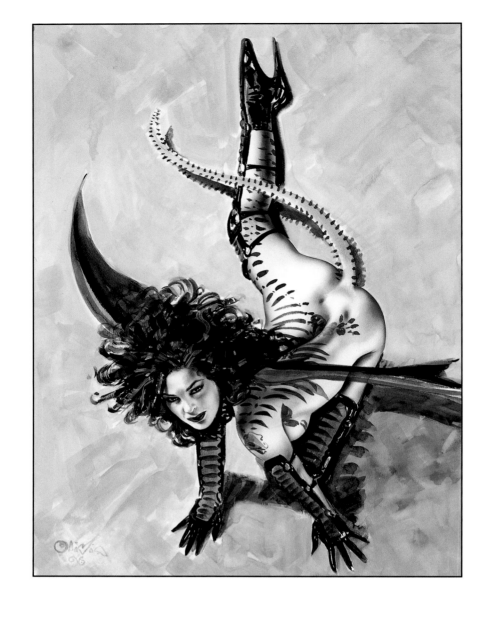

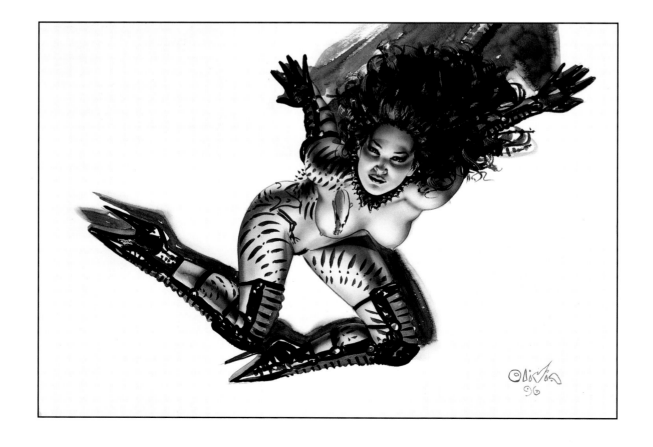

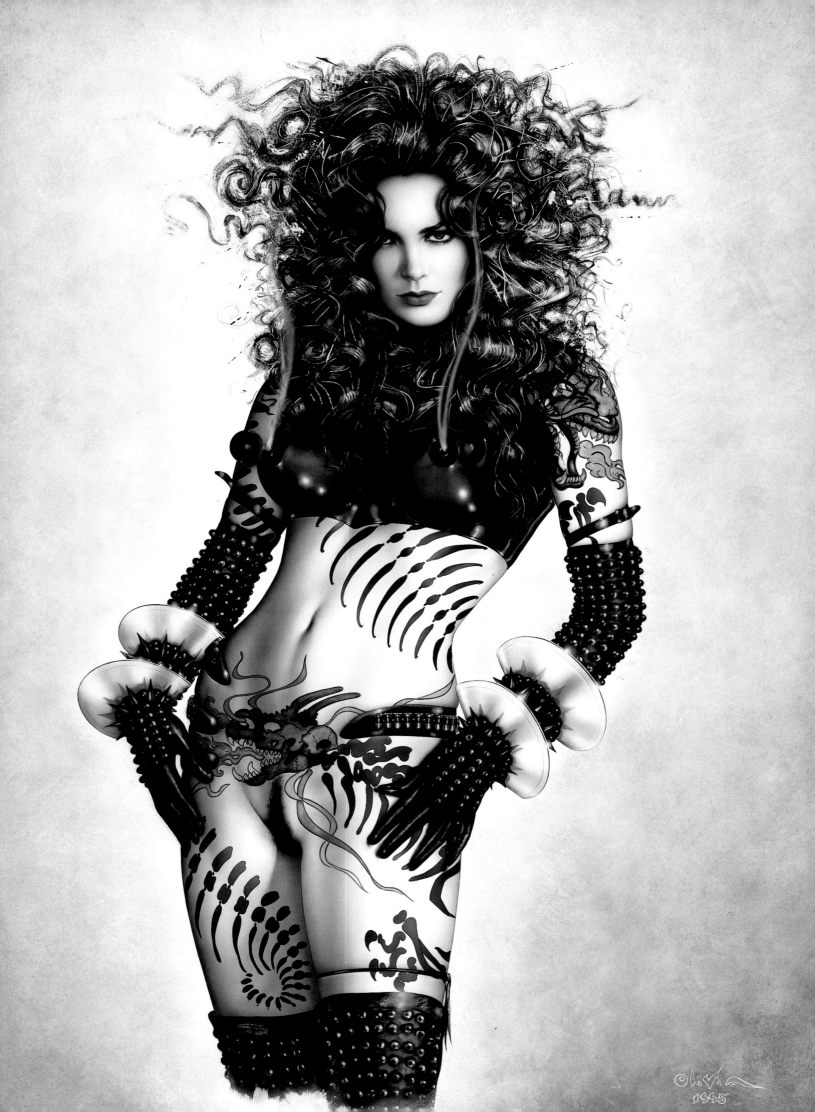

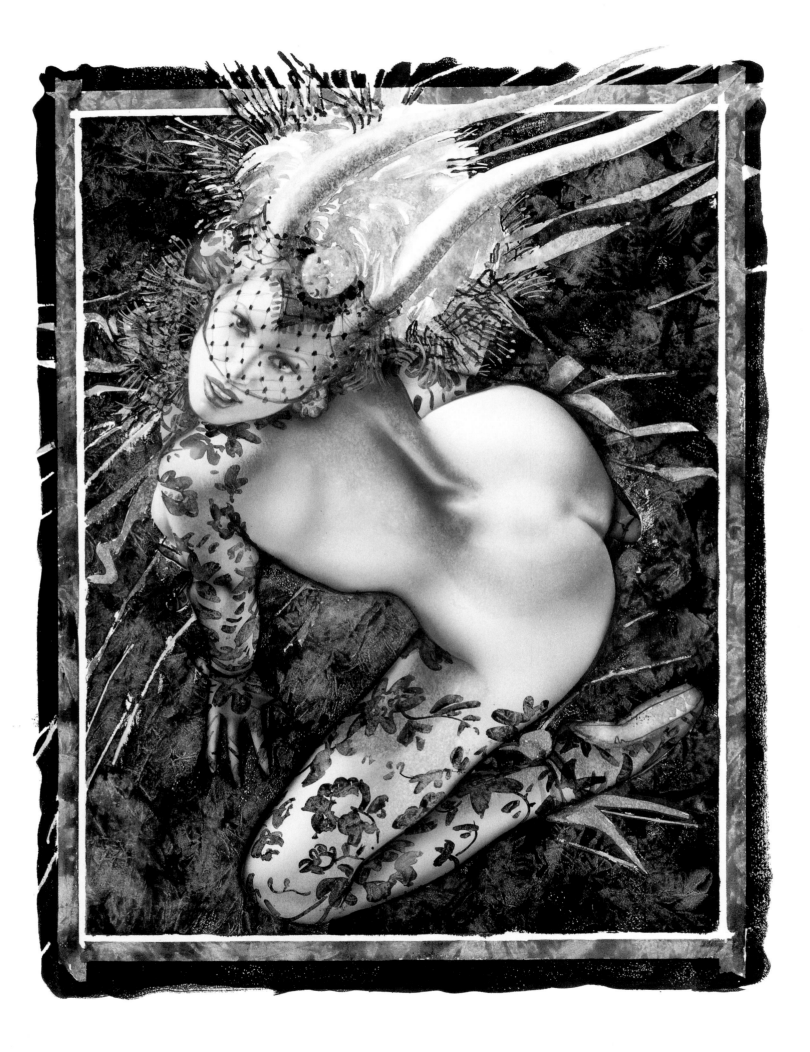

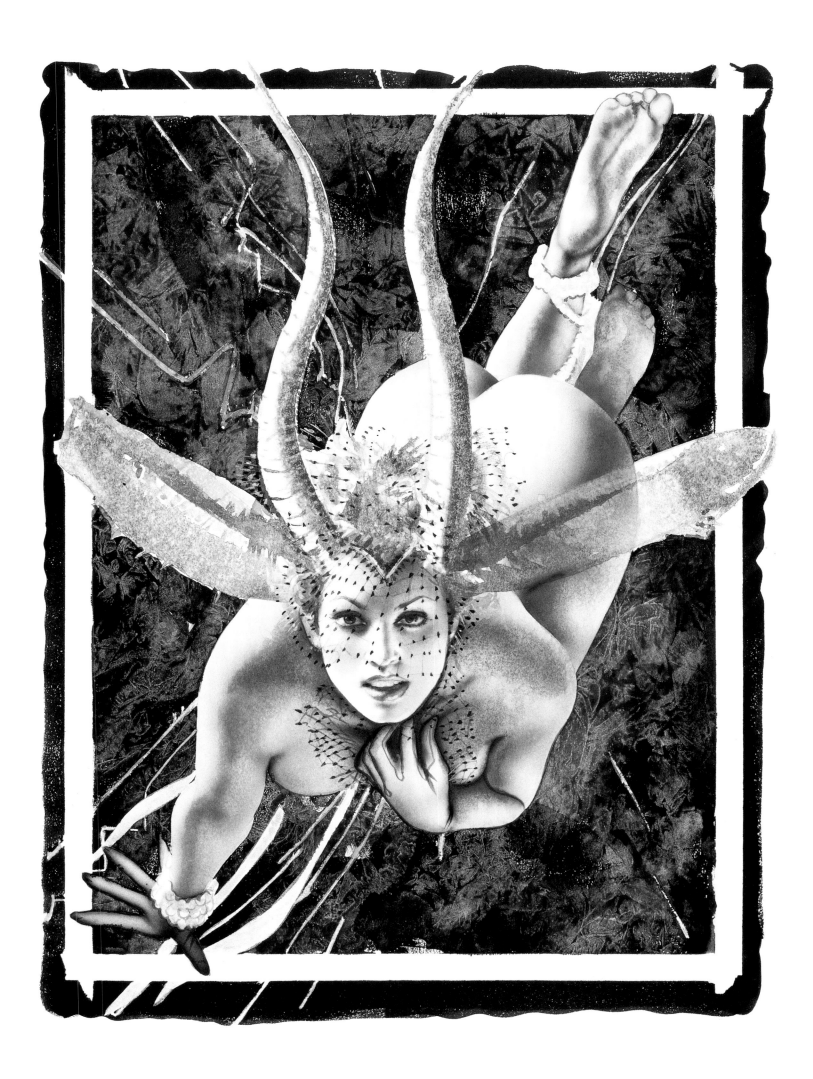

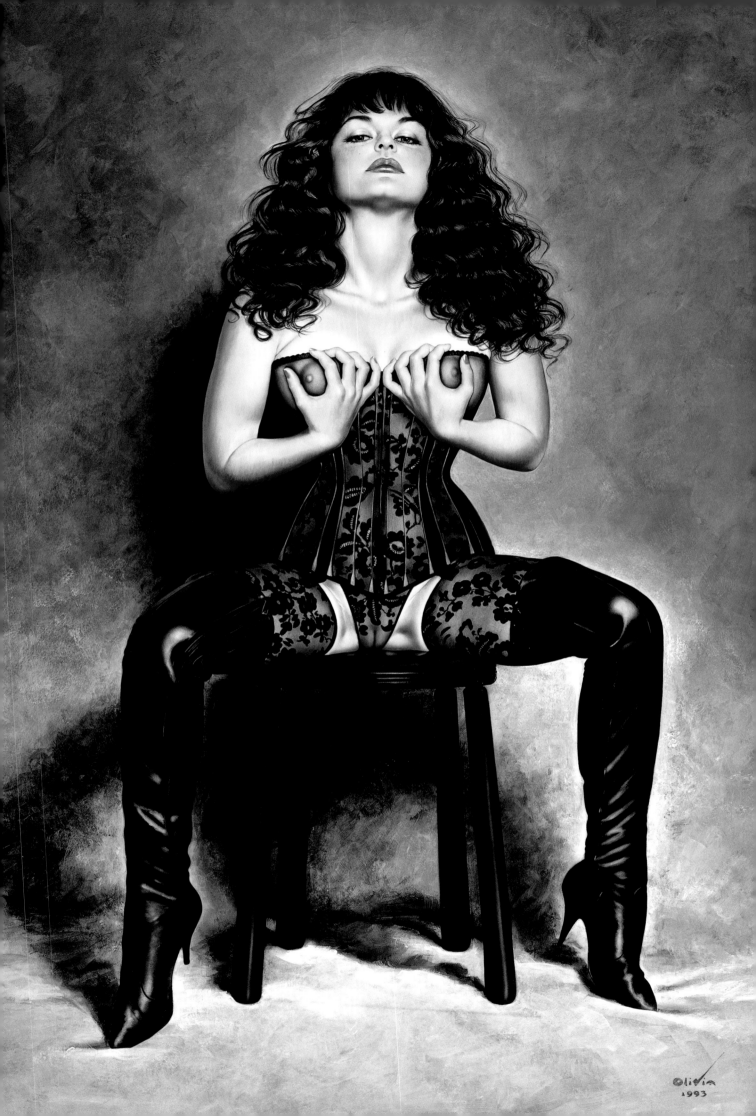

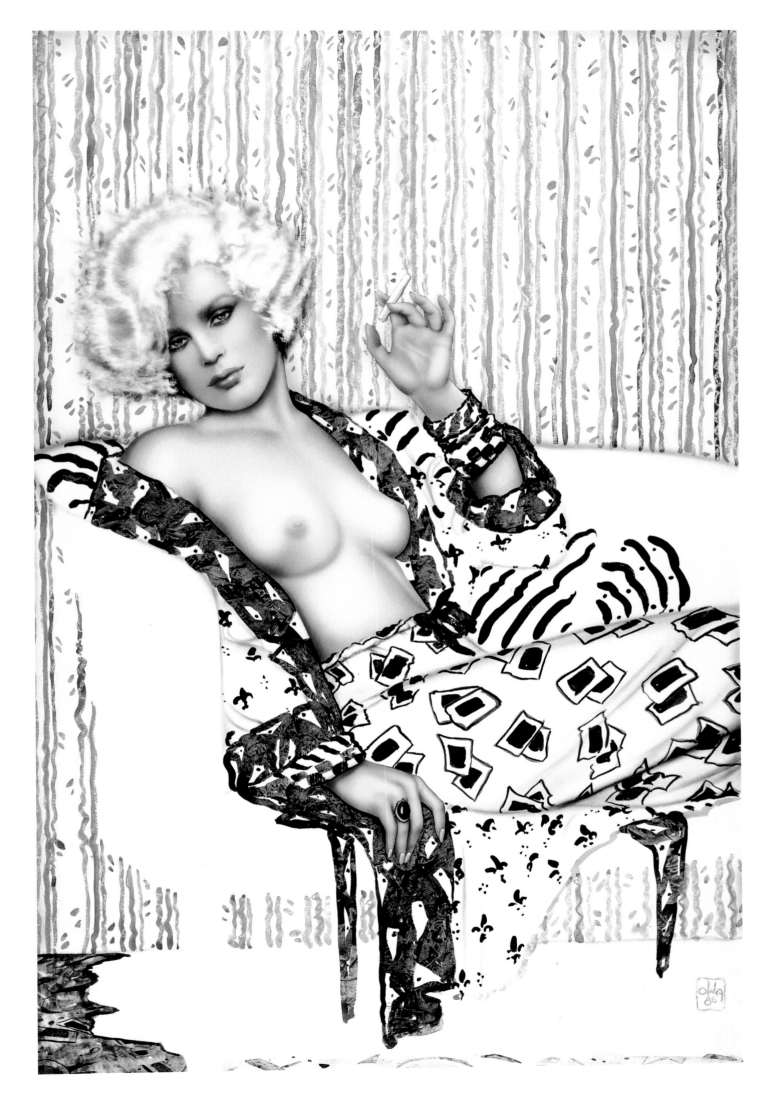

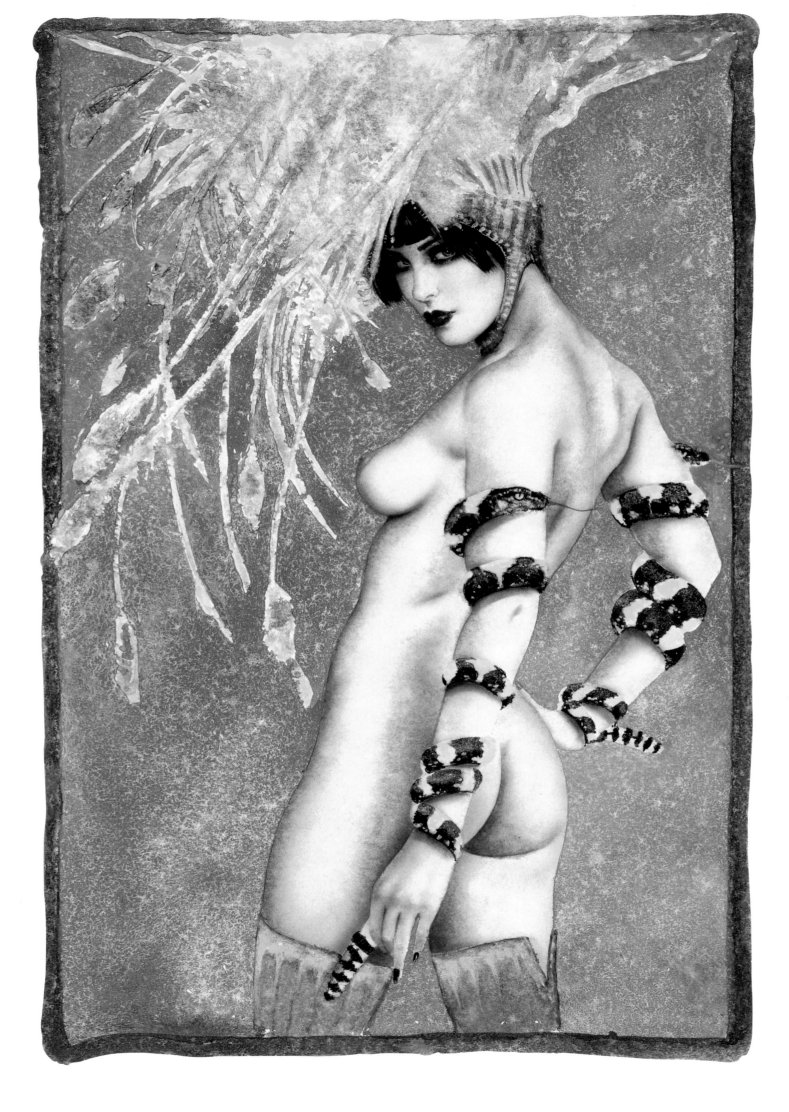

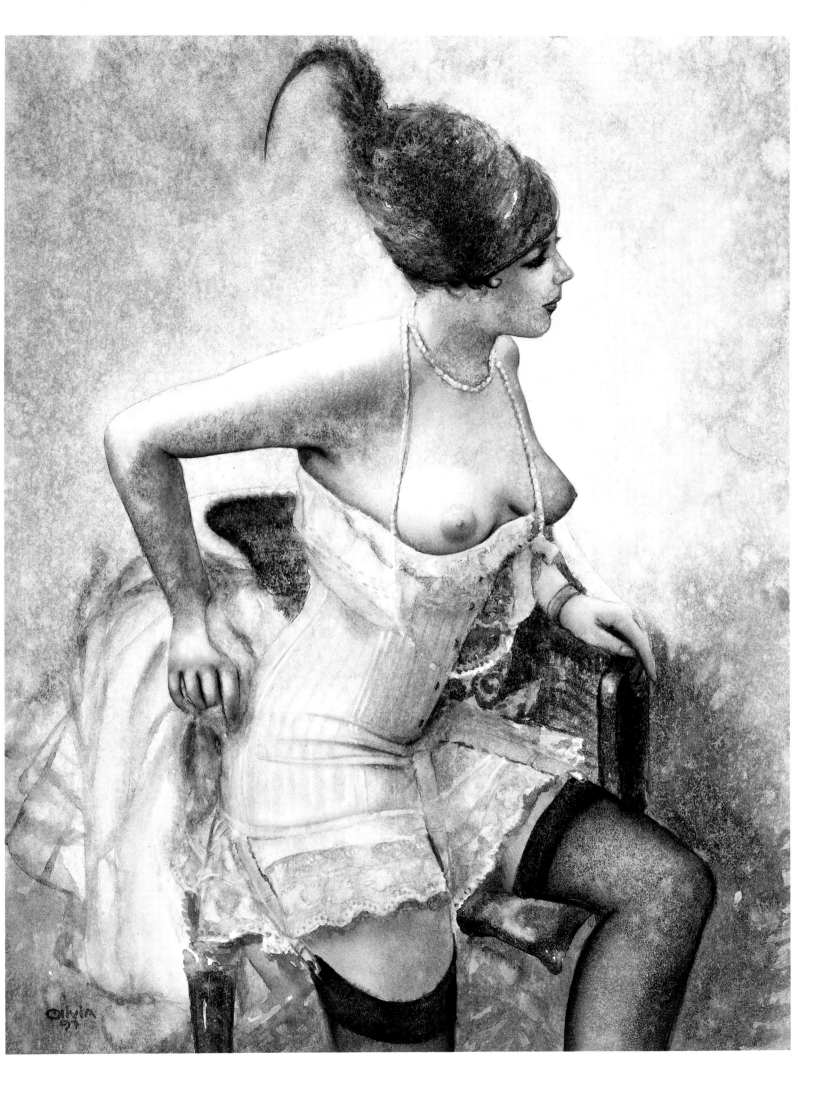

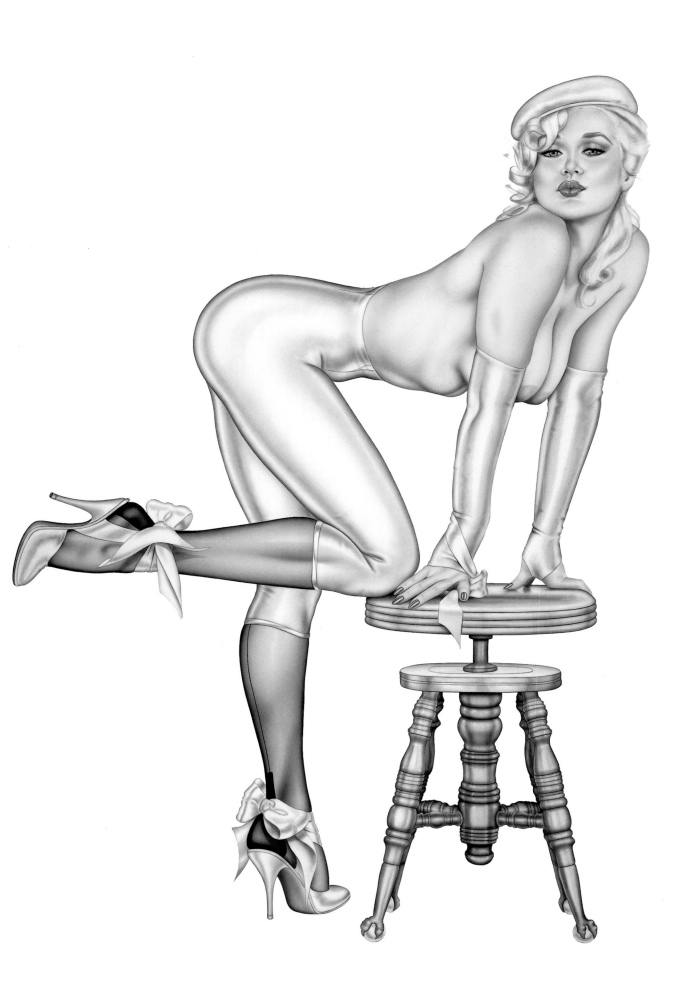

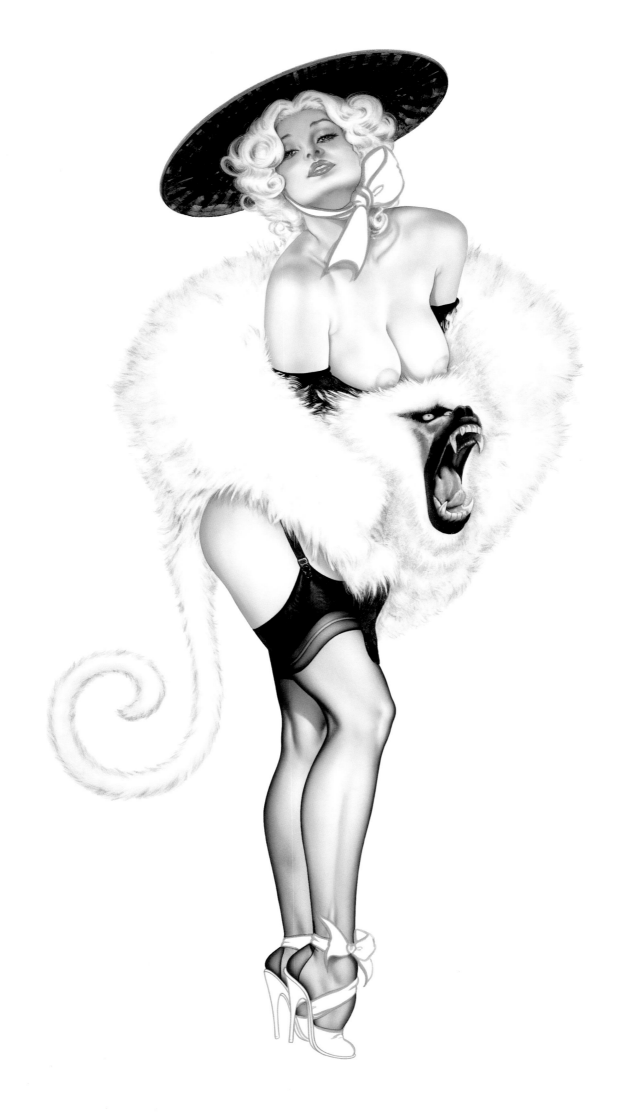

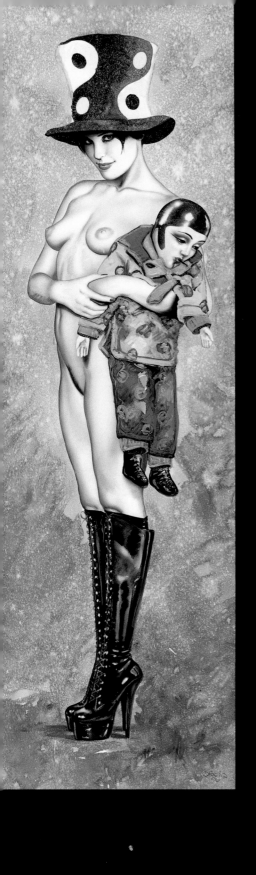
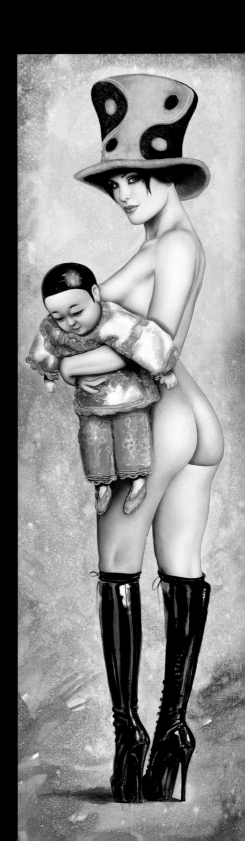

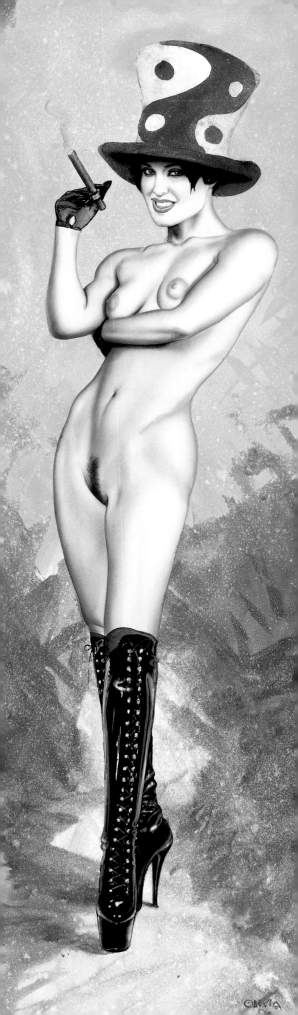

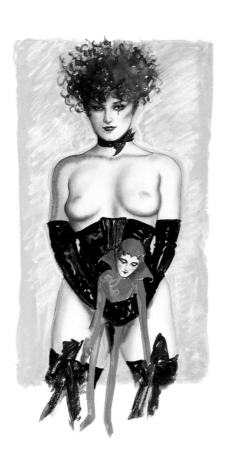

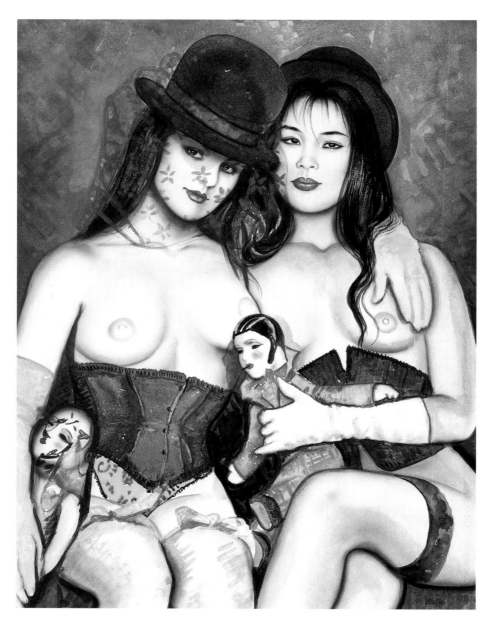

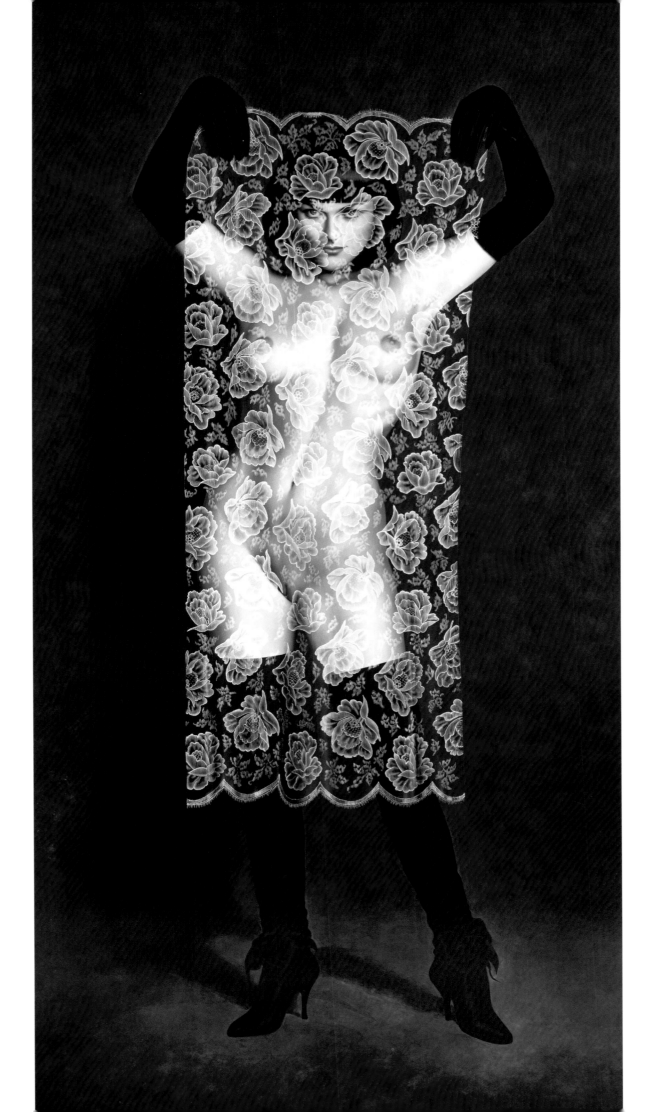

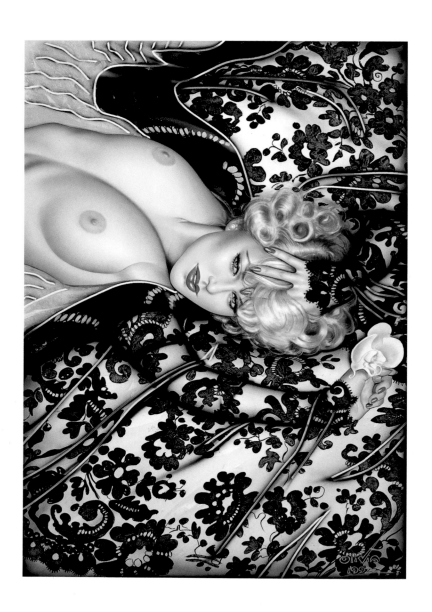

INDEX

Acknowledgements Page
1994, 10"x22", graphite on acetate. Model is Darla Crane.

Title Page 3
PIEWACKET III
1997, 10"x20", watercolor on board. Model is Bella Schol.

Page 4
REBECCA
1993, 15"X20", gouache on board. Model is Rebecca Ferratti. *

Page 5 Top
Untitled study
1993, 15"x20", watercolor and gouache on board. Model is Joséphine Baker.
> *Joel: "Photographic reference was another marvelous shot of Le Baker by the official photographer for the Folies-Bergère, known as Waléry. The feather costume may well have been created by Erté, who was doing set and costume design for the Folies-Bergère at that time, circa 1926."*

Page 5 Bottom
Untitled study
1996, 20"x15", watercolor and gouache on board. Model is Sandra Taylor.

Page 6 Top
TRACY II
1993, 15"x20", watercolor and gouache on board. Model is Tracy Tweed. *

Page 6 Bottom
Untitled study
1994, 20"x15", watercolor on board. Model is Erika Andersch.

Page 7
ERIKA
1994, 15"x20", watercolor and gouache on board, model is Erika. *
> *Olivia: "This is my favorite painting of Erika. You may know her from the television show American Gladiators, where she appears as "Diamond". She has great strength, her limbs float effortlessly in the air. This never happens to me. She is living sculpture. I love the feminine power, her buff butt, and yet, a Dietrich peek through the veil."*

Page 8 Top and Bottom
Untitled studies
Top is 1996, 10"x8", watercolor and gouache on handmade paper. Bottom is 1996, 20"x15", watercolor and gouache on board. Model is Julie Strain.

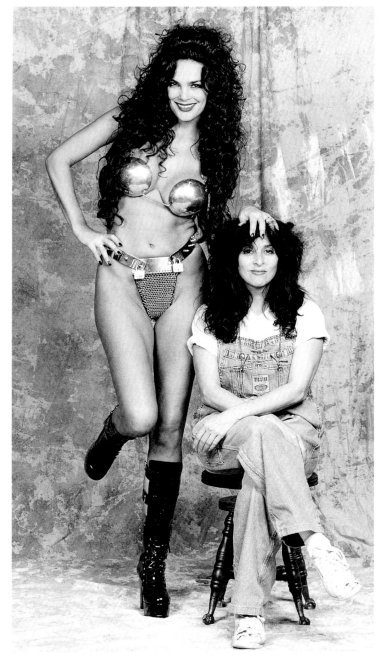

Julie and Olivia

Page 9
MISCHIEF
1995, 30"x40",gouache and acrylic on board.Model is Julie.*

Page 10
Untitled
1997, 15"x20", watercolor on board. Model is Bella Schol. *
O: *"I'll always love to paint Bella, a.k.a. Morbella, Isa, Isabella. She is one of my all time favorites. I've been painting her so long that I feel that she has taken on a separate life in my work. Bella now resides permanently in my own mythology, and in my fantasies, I travel with her on her wild and wicked adventures."*

Page 11 Top
Untitled study
1996, 8"x10", watercolor and gouache on handmade paper. Model is Rhonda Ridley.

Page 11 Bottom
Untitled study
1996, 9"x9", watercolor and gouache on handmade paper. Model is Julie.

Page 12 Top
Untitled study
1996, 15"x20", watercolor on board. Model is Sandra. *

Page 12 Bottom
SNAKE CHARMER I
1997, 20"x15", watercolor and gouache on board. Model is Julie. *

Page 13
TORPEDO
1996, 22"x30", acrylic on board. Model is Erika. *

Page 14
L8X DV8 I and **L8X DV8 III** (right)
1989, 22"x40", watercolor ,gouache and interference acrylic on board. Model is Bella. *

Page 15
L8X DV8 II
1989, 22"x40", watercolor and interference acrylic on board. Model is Bella. *

Page 16
TWO MINUTE WARNING
1986, 30"36", gouache and watercolor on board. Model is Lillian Müller. *

Page 17
MASQUERADE
1993, 24"x40", Acrylic on Gatorboard. Model is Pamela Anderson Lee. *

Page 18
PUCK
1995, 30"x 38", watercolor on board. Model is Blayne. *

Page 19 Top
TAKE FIVE
1994, 30"x40", watercolor on board. Model is Blayne. *

Page 19 Bottom
Untitled Study
1996, 15"x20", watercolor on board. Model is Blayne.

Page 20 Top
BOURBON STREET
1997, 18"x30", watercolor and gouache on board. Model is Rhonda Shear. *

Page 20 Bottom Left and Right
Two studies from the **ABDUCTED BY ALIENS** series.
1995, 18"x 24", watercolor and gouache on board. Model is Rhonda Shear.

Page 21
WHY MEN LEAVE HOME
1995, 26"x36",gouache on board. Model is Rhonda Shear. *

Pages 22 and 23
Studies for a gatefold cover for Playboy Magazine. Published here Courtesy of Playboy Magazine.
1987, 20"x 15", gouache on board.

Page 24 Top
RHONDA²
1994, 15"x20", watercolor on board. Model is Rhonda Rydell. *

Page 24 Bottom
Untitled Study
1994, 15"x20", watercolor on board. Model is Rhonda Rydell.

Page 25
NYLON JUNGLE
1992, 24"x40", watercolor on board. Model is Pamela. *
O: *"One thing that all the great sex idols have in common, what makes them legendary, is their sense of humor about themselves. They know what is inherently funny about their sexuality and capitalize on it. I always thought Marilyn Monroe was a great comedienne, she exaggerated everything sexual, she turned it on, she knew it wasn't real but got caught in the trap. Most people don't get the joke with our anointed sex queens. They expect them to actually be their film characters. Pamela Lee has now become one of these icons. She's always a terrific, funny lady to be around."*

Page 26
PURRFECT
1995, 30"x40", watercolor and gouache on board. Model is Monique Gabrielle. *

O: "I had great fun painting Monique in a Barbie doo. I knew she had a thing for cats, as her production company is titled "Purrfect". Monique stars in many B movies, and is known to her fans as a Scream Queen. This outfit reminded me of the great old stripper costumes from the fifties. I knew voluptuous Monique would love this. We framed the painting in a pink ostrich feather frame. When you walk by it, it dances, and Monique shimmies."

Page 27
Untitled Studies
1994, 15"x20", watercolor on board. Model is Monique.

Page 28
PIEWACKET I
1997, 15"x20", watercolor and gouache on board. Model is Bella. *

> O: "Here we find Bella explaining the rules of bullfighting and domination to my cats. These Siamese cats, Buffalo and Flatbush, lived with me day and night for the first fifteen years of my career in New York. When they died, shortly after we moved to California, I felt a whole chapter of my life ended."

Page 29 Top
PIEWACKET II
1997, 15"x20", watercolor and gouache on board. Model is Bella. *

Page 29 Bottom
Untitled
1981, 20"x15", gouache on board.

Page 30 Top
I'M NO ANGEL
1985, 30"x20", graphite on board.

Page 30 Bottom
LATE NITE
1985, 30"x20", gouache and pastel on board. Model is Karen. *

Page 31
HEAT WAVE
1985, 24"x36", gouache and pastel on board.

Page 32 Top
Untitled
1996, 8"x10", watercolor and gouache on handmade paper. Model is Blayne.

Page 32 Bottom
Untitled
1996, 8"x10", watercolor and gouache on handmade paper. Model is Jia Ling.

Page 33
The HAUNTING
1995, 48"x70", gouache on Tycor board. Model is Bella.

Page 34 Top
Untitled
1996, 8"x10", watercolor and gouache on handmade paper. Model is Lyniese Burks.

Page 34 Bottom
Untitled
1996, 15"x20", watercolor on board. Model is Lyniese.

Page 35
ZANZIBAR
1996, 26"x40", watercolor, gouache, and gold leaf on board. Model is Lyniese.

> O: "This sexy, sultry lady is a dancer. So we just put her music on and fired the camera quickly. In order to get a lot of the color I see in her skin into the painting, I used a spray bottle of distilled water and let the colors run together; light airbrushing over the skin, and gold leaf in her hair."

Page 36
ZEBRA LADY III
1994, 26"x40", gouache on board. Model is Rhonda Rydell.*

Page 37 Top
Untitled
1994, 8"x10", watercolor and gouache on acetate. Model is Florice Houde.

Page 37 Bottom
Untitled
1996, 20"x15", watercolor and gouache on board. Model is Julie.

Page 38
Untitled
1996, 15"x20", gouache on board. Model is Bella.

Page 39
VAMP
1995, 30"x40", gouache on board. Model is Linnea Quigley.*

> O: "Linnea is a Scream Queen, a veteran star of many horror and vampire movies. When she came to model, she brought her own bat props. Vampires evoke early glamorous Hollywood for me. This painting and **Things That Go Bump In The Night** (page 59) share her love of vampires, and my love of bats."

Page 40 Top and Bottom
Untitled
1996, 15"x20", watercolor on board. Model is Rhonda Ridley. *

Page 41
BAZOOKA
1991, 34"x108" and 24"x32", acrylic and gold leaf on canvas. Model is Pamela. *

Page 42
AUTO GYRO
1989, 30"x40", gouache, graphite and watercolor on board.
Model is Bella. *

Page 43 Top
MICHELLE Y
1987, 30"x40", graphite and watercolor on board. Model is
Michelle.

Page 43 Bottom
MICHELLE X
1987, 30"x40", graphite and watercolor on board. Model is
Michelle.

Page 44
KATA
1992, 15"x20", watercolor and gouache on board. Model is
Kata. *

Page 45
Untitled Studies
Model is Rhonda Ridley.
Top is pastel on gray pastel paper, 1992, 8"x 12". *
Bottom is watercolor on board, 1997, 15"x20".

Page 46
Untitled Studies
1996, 20"x15", watercolor and gouache on board. Model is
Julie.

Page 47
BANSHEE
1996, 30"x40", watercolor and gouache on board. Model is
Julie. *
> O: "Julie Strain is right up there with Bella and
> Rhonda Ridley for me. These are my most animated
> models. I've painted them over and over again, for
> years, because they have great versatility, camera
> sense, and their personalities are strong. I've only
> been painting Julie for two years now and she has
> been incredible. She has a large, aggressive cast of
> characters that I just play off of. She is my super-
> bitch-heroine-terminator. I had been sketching a
> predatory winged woman for a while and when Julie
> modeled for us again, I asked for this pose, which is
> actually a physically impossible position. We got
> close as we could, but what I had not foreseen was
> Julie's gift of a face for my creature. I manipulated
> the body into a lunging position. In ancient lore a
> banshee is a female spirit that wails outside a house
> as a warning that a death will occur soon. I wish all
> paintings would fall together so fast and magically as
> this one did. I knew where everything belonged.
> Maybe, I saw her in the neighborhood one moonless
> night."
> J: "The skeleton tattoo is what Olivia imagined a
> dragon skeleton would look like. Who could argue?"

Page 48
JEZEBELLA
1994, 26"x40", gouache on board. Model is Bella. *

Page 49
Untitled Studies
Top is 1996, bottom * is 1995, 20"x15", watercolor and
gouache on board. Model is Sandra Taylor.

Page 50
Untitled Studies
Top is 1994, 15"x20", watercolor and gouache on board.
Model is Florice Houde.
Bottom is 1994, 20"x15", watercolor and gouache on board.
Model is Florice.

Page 51
PORTRAIT OF A FIEND
1994, 24"x36", gouache on board. Model is Florice. *
> O: "Florice is a uniquely bizarre beauty. I grow
> dizzy from staring at all the tattoos, horns, piercings,
> and a small dotted branding on her arm that looks
> like lace. She has a strong sense of self and style. She
> runs her own fetish clothing company and when she
> came to model for me she brought her own handmade
> wardrobe which included her horns, hoof cane, coffin
> purse. Morticia Addams was a fantasy for me
> growing up and Florice fills that spot in my heart."

Page 52
JIA LING
1995, 20"x30", watercolor and gouache on board. Model is
Jia Ling. *
> O: "She was born in America, Jia Ling is her
> Chinese name. I so thoroughly enjoyed painting a
> woman of Asian descent because of all the delicate,
> subtle differences. And Jia Ling has such an elegant
> beauty."

Page 53
Untitled
1992, 20"x30", pastel on gray pastel paper. Model is Bettie
Page.

Page 54
AMBUSH
1996, 20"x30",watercolor on board. Model is Sandra Taylor.*
> O: "Sandra is one of my sexpot models. I think she
> is gorgeous! She has this natural teeth clenching
> grimace, a love snarl. Sandy is the perfect model for
> my classic pinup paintings."
> J: "Sandra has graced the covers of Playboy and
> Penthouse and, at the time we shot her, she was
> shooting the movie "Under Siege II"."

Page 55
Untitled Studies
Top is 1995, * watercolor and gouache on board, bottom is
1996, 20"x15", watercolor on board. Model is Sandra.

Page 56
Untitled
1996, 15"x20", watercolor and gouache on board. Model is
Bella. *

Page 57
Untitled
1996, 15"x20", watercolor and gouache on board. Model is
Bella. *

Page 58
Untitled Studies
Top is 1996, 15"x20", watercolor and gouache on board.
Model is Julie.
Bottom is 1995, 20"x15", watercolor and gouache on board.
Model is Sandra. *

Page 59
THINGS THAT GO BUMP IN THE NIGHT
1995, 30"x40", gouache on board. Model is Linnea Quigley.*
> J: *"Linnea shares our love of animals, and is very*
> *active in the animal rights movement."*

Page 60
GRAFFITI
1996, 22"x30", acrylic on board. Model is Jia Ling. *
> O: *"I think this painting best represents Jia Ling's*
> *personality. This is how she wanted to model, with*
> *her leather jacket and boots."*

Page 61 Top
Untitled Study
1996, 15"x20", watercolor and gouache on board. Model is
Julie. *

Page 61 Bottom
SNAKE CHARMER II
1997, 20"x15", watercolor and gouache on board. Model is
Shauna O'Brien. *

Page 62
Untitled
1995, 18"x40", watercolor and gouache on board. Model is
Julie. *

Page 63 Top
The SMOKING GUN I
1996, 15"x20", watercolor and gouache on board. Model is
Julie. *

Page 63 Bottom
The SMOKING GUN II
1996, 15"x20", watercolor and gouache on board. Model is
Julie.

Page 64
HEAVENLY BLUES
1993, 30"X40", watercolor and gouache on board. Model is
Bettie Page. *

> O: *"I took these great old Irving Klaw photos of*
> *Bettie and added outfits I thought would work with*
> *the poses. Bettie always exuded a lot of sexual ener-*
> *gy and spirit when she modeled in the 50's. She was*
> *fun to paint"*
> J: *"We acquired the rights to use these photos from*
> *Paula Klaw, Irving's sister."*

Page 65
HOT SAUCE
1992, 30"X40", watercolor and gouache on board. Model is
Bettie. *

Page 66 Top
Untitled Study
1996, watercolor and gouache on board. Model is Sandra. *

Page 66 Bottom
SNAKE CHARMER III
Models are Julie Strain (right) with Shauna O'Brien, 1997,
15"x20", watercolor and gouache on board. *

Page 67
SPONTANEOUS COMBUSTION
1996, 24"x36", watercolor on board. Model is Sandra Taylor.*
> O: *"When I paint Sandra I feel compelled by her*
> *cheesecake savvy to render her using the classic*
> *pinup styles. Here I reprised the style of fade-away*
> *made famous by the 40s pinup master George Petty."*

Page 68
Untitled Studies
1996, top is 15"x20", bottom is 20"x15", watercolor and
gouache on board. Model is Julie.

Page 69
SMOKIN'
1995, 30"x40", watercolor and gouache on board. Model is
Julie Strain. *
> O: *"This was the first fully realized painting I did of*
> *Julie. I had been doing a lot of studies of her in sci-*
> *fi outfits. Certain models lead me to styles of paint-*
> *ing and Julie's aggressive posing led me, irresistibly,*
> *to this image, which is a visual pun of a woman who*
> *uses her breasts as weapons. I also remembered an*
> *Italian sci-fi movie from the sixties with Marcello*
> *Mastroianni and Ursula Andress called "The 10th*
> *Victim", in which Ursula, dancing at the Club*
> *Masoch, shoots her victim with guns hidden in her*
> *bra."*

Page 70
Untitled
1997, 15"x20", watercolor and gouache on board. Model is
Sandra Taylor. *

Page 71
Untitled
1997, 15"x20", watercolor and gouache on board. Model is
Sandra. *

Page 72 Top
Untitled Study
1989, 20"x15", watercolor and gouache on board. Model is Rhonda Ridley.

Page 72 Bottom
OORT ZONE
1988, 32"x30", watercolor on board.

Page 73
STILETTO
1993, 48"x66", acrylic on Gatorboard. Model is Cindy Daguerre. *

O: *"Cindy's face has a vicious childlike innocence. I love the hostility in this seemingly giving pose. It's this anger in her sexuality that makes me love to paint her."*

Page 74
FRENCH BRITCHES
1988, 20"x30", watercolor and gouache on board.

J: *"Olivia used a photograph for reference on this painting, which came from my collection of French lingerie catalogues from the 1920's and early 1930's. This image came out of a **Diana-Slip** folio that was created by the husband/wife team known as **Yva Richard**. The same photo sources were used for **Oort Zone** (page 72)."*

Page 75
BOULEVARD VAMP
1986, 20"x30", watercolor and gouache on board.

Page 76
THE FRENCH QUARTER
1997, 18"x28", watercolor and gouache on board. Model is Shauna. *

O: *"I've been experimenting with the happy accidents that occur when using a technique called "wet into wet". I was also using a spray bottle filled with distilled water and letting the drops form patterns on the paper."*

Page 77
POSTCARD FROM PARIS
1997, 15"x20", watercolor on board. *

J: *" Olivia found the photo reference for this watercolor in our collection of French postcards of the 20's."*

Page 78
ANGEL CAKES
1990, 30"x40", watercolor and gouache on board. Model is Rhonda Ridley. *

Page 79
COCONUTS
1993, 30"x40", watercolor and gouache on board. Model is Rhonda Ridley. *

Pages 80 and 81
Untitled
1996, 15"x40", watercolor and gouache on board. Model is Shauna O'Brien.

Page 82
Untitled Studies
Top is Cindy, 1994, 15"x20", watercolor and gouache on board.
Bottom is Cindy (left) and Jia Ling, 1996, 15"x20", watercolor and gouache on board.

Page 83
PIERCING THE VEIL
1993, 42"x96", acrylic on Gatorboard. Model is Cindy Daguerre. *

O: *"Cindy is a descendent of the famous Frenchman who invented the daguerreotype. She posed with a length of Chantilly lace. I asked her to put her gloves on and when she raised the lace, it framed her and gave us this beautiful, mysterious pose. This painting is 8 feet tall, done in acrylic, a lot of brush work, and a small amount of airbrush. Painting the lace felt like I was actually hand crocheting it, and since you ask, it took about 2 months to complete."*

Page 84
RHONDA I
1992, 15"x20", watercolor and gouache on board. Model is Rhonda Ridley.

Page 95
GINGER SNAPS
1992, 30"X40", watercolor and gouache on board. Model is Rhonda Ridley. *

All photographs used in this book are:
Copyright © Joel Beren
All Rights Reserved.

Olivia's artboard, as described above, and in the techniques section is made for her by Framing Technology, Inc. For information contact:

Framing Technology, Inc.
1528 N. Bonnie Beach Place
Los Angeles, CA. 90063
Phone: (213) 980-8200
FAX: (213) 980-8207

For information about licensing the artwork in this book, and all other artworks by Olivia, contact:

OZONE PRODUCTIONS, LTD.
@ Joel Beren: President
P.O. Box 4153
Point Dume Station
Malibu, California 90265
PHONE: 516-621-8484
FAX: 516-625-8715

For information and catalogues of other products featuring Olivia's art, including postcards, greeting cards, calendars, posters, and books, contact Olivia's publishing and mail order company:

Ozone Productions, Ltd.
and **O CARDS**
P.O. Box 111
Roslyn, New York 11576
Phone: 516-621-8484
FAX: 516-625-8715

For on-line information about upcoming art shows, catalogues, and contests visit Olivia's official website at **The PINUPMALL**:

http://pinupmall.com

All original artwork and limited edition prints are available from Robert Bane Editions.

* *The asterisks ** in the index text above signify that the art so notated is available as limited edition prints or giclees.
For information contact:

Robert Bane Limited, Inc.
460 North Rodeo Drive
Beverly Hills, California 90210
Phone: 310-205-0555
FAX: 310-205-0794

To see Olivia's original artwork, please visit The Tamara Bane Gallery in Los Angeles:

Tamara Bane Gallery
460 North Rodeo Drive
Beverly Hills, California 90210
Phone: 310-288-5932

OLIVIA'S TECHNIQUES

I remember when I first started my career I was looking for help with technique. I found all the technique books hard to understand. You have to experiment and work through your own problems and find your own solutions, which will eventually evolve into your own style. It is hard to write down what I do instinctively, what I have learned over the last 25 years as a professional. I'm sorry it can't be clearer. I can only provide some details on materials and how I use them. Writing about obsessive behavior in a techniques page is frustrating. I hope that this will give you some ideas.

Olivia and Lyniese

EARLIER ACRYLIC PAINTINGS such as **Piercing the Veil**, **Bon Bons,** and **Stiletto**:
These paintings were done on a smooth surface, lots of brushstroke and a lot of handwork, using light touches of color mixed with a small amount of white and gloss medium. Covering the body in small dabs of color, building up the paint slowly, using the airbrush, a Paasche AB, occasionally through the course of the painting. I'm trying to escape overusing the airbrush, which, I've come to feel, lacks the passion I seek in my paintings. I try to combine a predominance of brush work with the airbrush.

RECENT ACRYLICS such as **Fallen Angel**, **Graffiti**, and **Stardust**:
I started using a very hearty board with a lot of texture, Arches watercolor paper mounted on an archival board, because I wanted less obsession with details, and more action through the actual paint and color. I find that smooth board encourages obsessive rendering. I outline the image and start to spatter the board and drag the paint, usually with a rubber paintbrush "color shaper", creating brushstrokes with it. I then work on the image, which goes in and out of focus. I obsessively keep bringing in the image and then splattering it until I'm either satisfied or nearly insane. Glazing is used to bring the deadness of acrylic to life, layer upon layer of spatter and image build up, with lots of gel medium adding to depth and texture. For information about this board, see page.....

CLASSIC PINUP such as **Rapunzel**, **Erika**, and **Angel Eyes**:
I work on a drawing until I'm satisfied. I transfer the drawing by redrawing the finished sketch on the reversed side of the tracing paper, appropriately positioned, and rubbing it onto the board. I paint in a light outline, with Winsor-Newton's burnt sienna, erase the pencil lines with a kneaded eraser, and proceed to build up the painting in extremely light tints of burnt sienna. I use a sable brush, and in my left hand I have another brush dipped in clean water to blend the tint. Other colors are now added, but values are brought up very lightly and slowly. Bring it up too fast and it looks "overcooked". If you are patient, you will see the whole painting, done only in washes. At this point you can usually fix any problem areas by erasing or lifting the color with water. Now I start to airbrush. I like to use my airbrush as a polishing tool, and I should be satisfied with the painting before I pick the airbrush up. My black backgrounds are painted with a velvety jet black by Holbien.

LOOSER PAINTINGS such as **French Quarter**, (Bella Faces):
These are a combination of watercolor and gouache. Each varies, as I am always experimenting, looking for "happy accidents" with color running into color. I may be splattering and dragging rubber brushes across the wet color for effects. Or, I sometimes use a spray bottle of distilled water at various times during the painting, and the amount of airbrushing used on the body varies from slight to not at all. **Banshee** was a large version of these roughed up boards, done mostly in gouache. The background was done in watercolor, rubber brushed, paint splattered over the image, and gouache was airbrushed in at the end, to make the body jump out more.

GOUACHE PAINTINGS such as **Tapioca**, and **Smokin'**:
Some have watercolor bodies with clothing and background in gouache, such as **Doll Wars**. Every once in a while, I will use white gouache in the skin as in **Satin Under Siege**. The more recent paintings have brushstrokes in the background.

BACKWORD

Some people are born under a bright star, which illuminates the path. These people seem to know what they want to do with their lives almost as soon as they can understand it. They spend their early years learning the things which will aid them in achieving their ultimate goals. Although she might argue the point, Olivia is one of these fortunates. She spent much of her childhood drawing and was schooled in the arts. My star was a bit dimmer. Most of my wasted youth was misspent because I was so clueless. My family was overloaded with professional types, mostly doctors. I knew this wasn't for me. I graduated from a midwestern university still not knowing, hence, my degree in philosophy. I entered the business world, and soon maneuvered to a job in New York, selling. It didn't matter what. I was in New York. At the time, this alone seemed a worthy accomplishment. I spent 8 unsatisfying years in the garment center. Friends would often ask me what I was doing there. I guess they could see what I couldn't, that I wasn't fulfilling my potential.

I'm a born collector. Those of you with the malady will understand. Bottle caps, rocks, coins, stamps, it didn't matter. And I was fortunate in New York to encounter some collectors that opened my eyes to worlds I hadn't realized existed, which really didn't exist in the Cincinnati of my youth. And so I started to amass a respectable group of things disreputable; erotic photos, books, and art, back when these things were still around and affordable, if you simply had the nerve to ask for them. Curiosa. Vintage Erotica. Fancy euphemisms for what interested me. Frankly, I wasn't very interested in the spate of mass produced pornography. It seemed largely to appeal to a baser level than the vintage material in my collection. Perhaps, it's just that I preferred the patina that age and distance conferred.

One day a friend showed me a portfolio of photo reproductions of artwork that really excited me. This friend knew that I collected erotica, and thought I might want to buy a painting. I asked to meet the artist, Olivia De Berardinis, and soon my life changed in a profound way. Suddenly I had a reason, a purpose, and goals. I also had a tremendously exciting and unanticipated complication, a lover. I became Olivia's promoter, publisher, manager, and most outrageous of all, her husband. And that was more than 20 years ago. We have a uniquely satisfying relationship because we really do complete each other. I was reluctant initially to involve myself in the business dealings of the woman I was infatuated with. It seemed like a good way to screw things up. But for the first time in my life, I had a product that I really believed in, that I knew was the best there was, within the context of the pinup or erotic art world. Frankly, I was making more money, much easier, in the garment center. But I didn't enjoy what I was doing. Now I had a chance to do something which I truly believed (and still do) was valuable.

I saw Olivia's talents, in their early stages, as being important and large, but equally fragile and easily diminished. It quickly became clear to me, that for Olivia to develop and grow to her full potential, she had to be kept out of the hands of the eager art directors of the commercial flotsam, that seduces and destroys so many talents. By creating a small publishing business, we were able to provide enough income for a comfortable, but not too comfortable, existence. We could afford to indulge in art supplies and explore new techniques and materials. Her inquisitive nature, which remains undiminished, keeps her work changing and vibrant, even though the basic subject never changes. I think this book is ample proof of her evolution. If you look at the dates of the paintings in the index, you may start to discern patterns in the approach, the techniques she uses. And Olivia is, by nature, never satisfied with her work, always seeking to improve it, to hone some skill or attempt to master another. She tends often to dislike her own efforts, which she feels fall short of the vision she had originally in her mind. The good side to this is that it keeps the work vibrant, fresh, exciting. The downside is that it makes it very difficult for Olivia to forever be forced to smile and sign copies of art she no longer likes. This is a source of great sadness to me, because I love all of her work, admittedly in varying degrees. It is an endless source of pleasure for me to watch her create, to watch the paintings come to life, and then to leave our hands and truly take on a life of their own. And here lies the key for me, what makes me happy to get out of bed each day, and we generally work 7 days a week. It's mostly great fun. And I love being a part of creating something that, in my eyes, is beautiful. There certainly is enough ugliness to go around. If we can expand the universe of the beautiful, just a little, it's been a very good day indeed.

Joel

RAMBLINGS FROM THE ARTIST

I used to be mesmerized by the old movie queens when I was growing up. I fantasized through them, these were super women, and the movies made it seem anything was possible. I still enjoy escaping into this world of seduction and glamour, where it seems you can only play those games and live those fantasies if you live on film or paper. Every woman has her own cast of characters and somewhere in every brain there is a small space, where we are playing all these outrageous games and rituals and they are actually working! You're make-up stays on, your panties don't bunch up, and your partner is perfect. I know we have many roles, but seductress is one we all play at one time or another, if we want life's cosmic joke-sex. Now your idea of seduction may not look like my paintings, but you are doing some dance. Nature sometimes makes us act in, what I find, hilarious rituals. If you were a space alien and you came down to earth and saw us mate, would it be much different than when we watch nature shows? Can't we really compare the mating game of, say, the blue-footed boobie to a love scene between Gable and Lombard?

I would watch my mother, who was very sexy, prepare for a party like war, running around scaring me with her green mud mask, her pink rollers. She looked like an Alien possessed getting into her girdle, her stockings, her 50's bullet-type bra, tight satin dress and stiletto heels. She would transform into this goddess, for whom my father's sole purpose was to prop her up for the night. It was funny. I did it myself. I take some of these joyous moments of flirtation, and try to dignify them. There is a fine line between vulgarity and the sublime. I teeter on it, and when I am successful, I have an image that, like the movie queens, lives and loves forever. When I fail it becomes all too real.

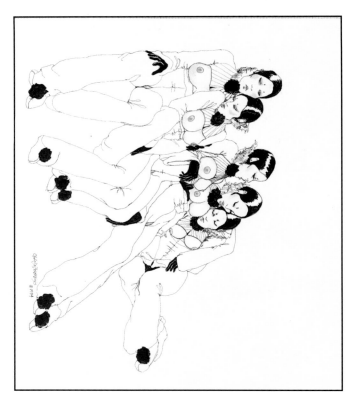

We have been doing body modification since the beginning, whenever that was. Archeologist find mummified bodies with tattoos and piercings. China had a 1000 year old foot binding fetish which crippled women. Lips stretched, labia elongated or excised, ribs removed to fit in corsets, toes removed to fit in pointed shoes. Women were not always the victims in these fashion fetishes, as so many assume. Some were willing partners in a game played by both sexes. Men also have had a similar, and equally bizarre litany of fetishes. We have created our own ideals of beauty which continually evolve. The standards of beauty of the past may seem odd to some of us today, but their beauty held many meanings; status, domination, possession. We've always needed to re-shape our universe, our bodies, re-invent ourselves. Today, with body sculpting and breast implants, we have a bionic muscularity, an almost Alien look emerging. We've been playing with Barbie for 35 years, designed by a woman originally, we really designed her as a collective consciousness and accepted her as a bonafide beauty, which some women try to attain. The sexuality of my models has been shaped by some or all of these forces. I am in an artistic collaboration with these women. And I am hoping to create fantasies that are archetypal. When men paint women, they are painting what they desire. This is valid. I'm painting from an owner-friendly point of view. I know the territory, and I know how it works. I call this *sexual portraiture*.

Page XVIII
SNAPDRAGON
1993, 40"x30", watercolor and gouache on board.
Model is Erika Andersch. *

Page XIX
STARDUST
1996, 66"x36", acrylic on Tycor board. Model is Blayne. *

O: "In real life Blayne was once a ballerina. I love dancers, they defy gravity. I love the control, the disciplined body. It is nothing natural, it's exaggerated, much like my work. Being a ballerina is a childhood fantasy, that I still have. Painting Blayne keeps me from prancing around in a tutu."

Page XX
CARNIVORE II
1996, 78"X 40", acrylic on canvas. Model is Tracy. *

O: "Trying to make these paintings work was overwhelming to me, so I abandoned them for a few years. But something kept drawing me back to the canvases. I found them mesmerizing. The stalking poses and sultry looks were given to me

Page XXI
CARNIVORE I
1996, 78"X 40", acrylic on canvas. Model is Tracy. *

J: "I am forever grateful to Tracy for giving us these raw, uninhibited poses. They we're just what Olivia needed to inspire her to create these otherworldly creatures."

Rhonda Ridley and Orbit

stuffed animals. I have never seen such a wardrobe! At times she looked much like a life-sized Barbie. Rhonda had a bra that would have matched Carmen Miranda's fruit laden head gear. Space outfits, space earrings, space guns. It turns out she had been abducted by Aliens and forced into bearing their young! I read that in a tabloid (while waiting to buy some groceries), so it must be true.

Rhonda, who often does stand up comedy in Vegas and at comedy clubs around the country, said she didn't see herself as a serious pinup, and wanted me to paint her with toilet paper stuck to her heel. We may never know why the Aliens let her go, but we're mighty happy to have her back."

by our model, the always elegant Tracy Tweed. At first, they had black spots, but I thought the orange spots were more believable. Hairy backs and big fluffy paws made them look like escapees from "Cats". Eventually, I found the right balance between cat and human. Whenever I see the big cats, I am so overwhelmed by their beauty and power, and the patterns on their bodies, like tattoos."

Page XXII
Details from Carnivore I & II (previous pages).
Page XXIII
Detail from Fallen Angel (page XXV).

Page XXIV
3 studies for Fallen Angel, 1994, each sized 30"x20", watercolor and gouache on board.

Page XXV
FALLEN ANGEL
1995, 84"X42", acrylic on Tycor board. Model is Rhonda Ridley. *

O: "The three small preliminary paintings show how I go about working out possibilities, and some other directions I might have gone. I collect boudoir dolls (antique dolls of adults made for adults) and thought at first she looked like an old French postcard of a model holding a doll. I also had difficulty with the placement of a long tail. The cat appeared in the second study because I was remembering "Bell, Book and Candle" with gorgeous Kim Novak as a witch who used a Siamese cat as her "familiar" to cast spells. I shortened the tail but it started to look like a thick, red penis. But, I wanted it to be all female. With so much going on, my solution was to simplify. That way the viewer's attention goes to the faces first. The final painting is a 7 foot long acrylic, painted on Arches paper, custom-mounted on a thick honeycomb-corrugated archival board. The wings and horns started out pink, but red won out.
In this final version I'm not sure who the domina is, the woman or the cat? I see them as two expressions of one persona, id and ego."

Page XXIX
PIEROT LADIES
1974, 12"x10", pen and ink and make-up on paper.
O: "I used facial cosmetics to color this drawing."

INDEX

Pages II, XXVI, and 91, 93
Untitled
1973, 8"x10", pen and ink on vellum.

OLIVIA: *"These little pen and inks were created 25 years ago. At the time I was a waitress at a Greenwich Village spot called Shakespeare's. I was doing minimalist paintings, but I found it was impossible for me to excel at this. I didn't have the education or intellectual rap. There weren't a lot of women showing in New York galleries in the early 70's, although I was in a few group shows. I was doodling these little women in my spare time. They all had attitude and were sexy. Sometimes they held little gargoyle-like beasts with large phallic striped tails. People often ask me how I got started doing my art? Well, I could see that I would be waitressing for a very long time before I made a dent in the fine art market. This depressing vision started a little fire of desire in me. I was 25 and it was time.*

So I quit my job and borrowed $2,000 from my parents, which got me a new apartment and a clean start. I then proceeded to discipline myself and developed rather fanatical work habits. Previously, my work pattern consisted of waiting for inspiration, and then I would paint, and then I would wait for the next lightning strike, which, at the time, occurred about once every six months. Now, I sat down every day, inspired or not, and forced myself to work. I pulled together a black and white portfolio. The subject was clear to me from the start. I had always drawn women. I took this portfolio and went to the sex magazines. I chose the sex magazines because I had no confidence and no formal training in illustration, and wanted to learn on the job. It seemed to me that the competition wasn't as fierce in the world of the skin mags. They were rough beginnings, but after a year or so I started getting more jobs and soon the art directors let me be creative within the confines of the assignments. I was enjoying myself.

Joel came in and out of my life at the beginning, but, faced with my beastly ill-tempered boyfriend, he took a sabbatical for a year while I sorted things out. He came back into my life, and in '77, he started the O Card Company to promote me. Initially, we started with 6 greeting cards. We married in '79 when we were both 30. I continued to work for the magazines for a few years, while Joel represented me and expanded the card company. This gave us the financial freedom to allow me to create what I wanted, without having to worry about pleasing an art director.

Robert and Tamara Bane started their publishing business in '84, with the initial purpose of publishing my art as limited editions. This relationship gave me the opportunity to expand and elaborate on my pinup art, to show and to grow. I think this is where most artists have a hard time, trying to do their own business and still get

the artwork done. Joel took over all business transactions, expanded the card company, worked out my contracts.

As the years progressed, I had a growing body of work, and in '93 he designed and published our first book, "Let Them Eat Cheesecake". Joel and I, over the years, have become partners in even the execution of the art. He photographs the models, prints the copy photos, suggests and critiques, then ducks, and when the work is finished he even shoots the art photocopy. Joel was, before I met him, an avid collector of antique erotica, and still is. This has been a valuable data base for me. We have become such an integral part of one another, it gives us a power base. I consider the art ours."

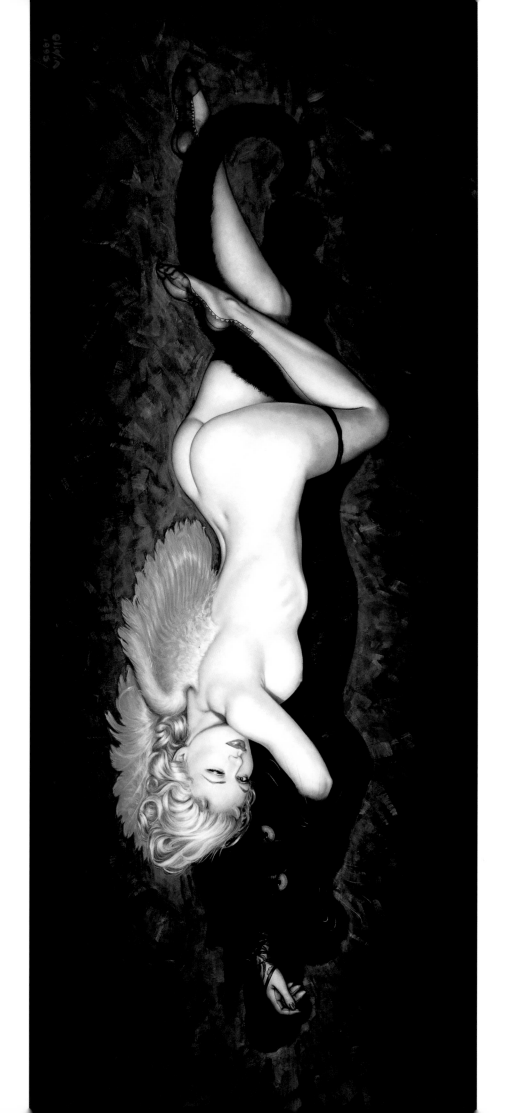

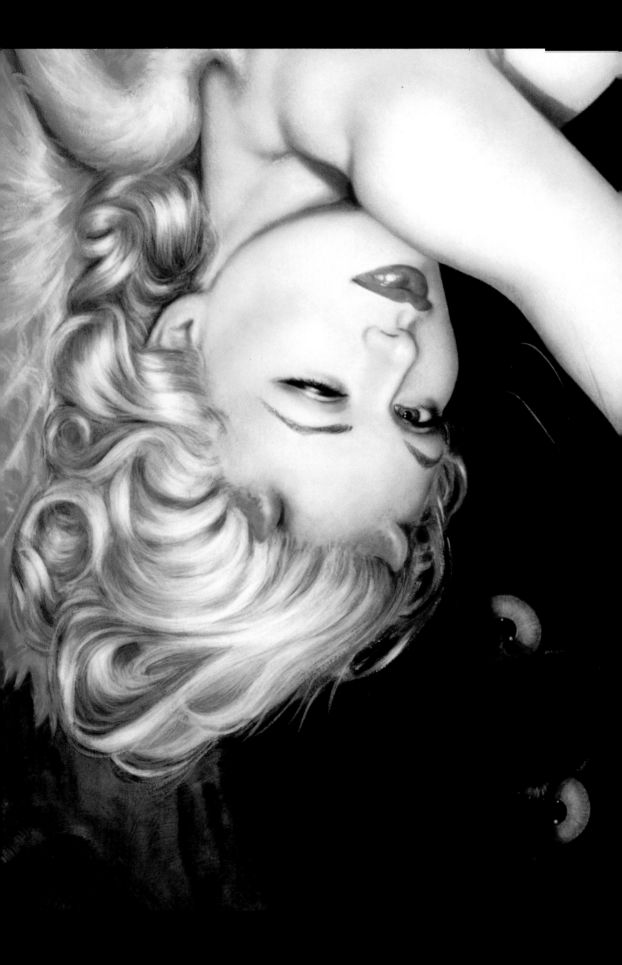

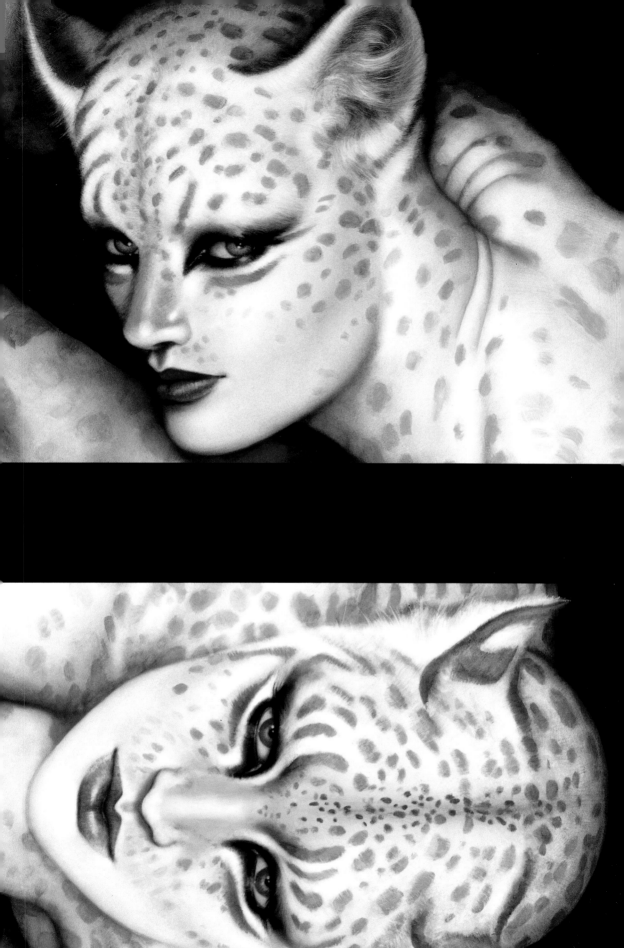

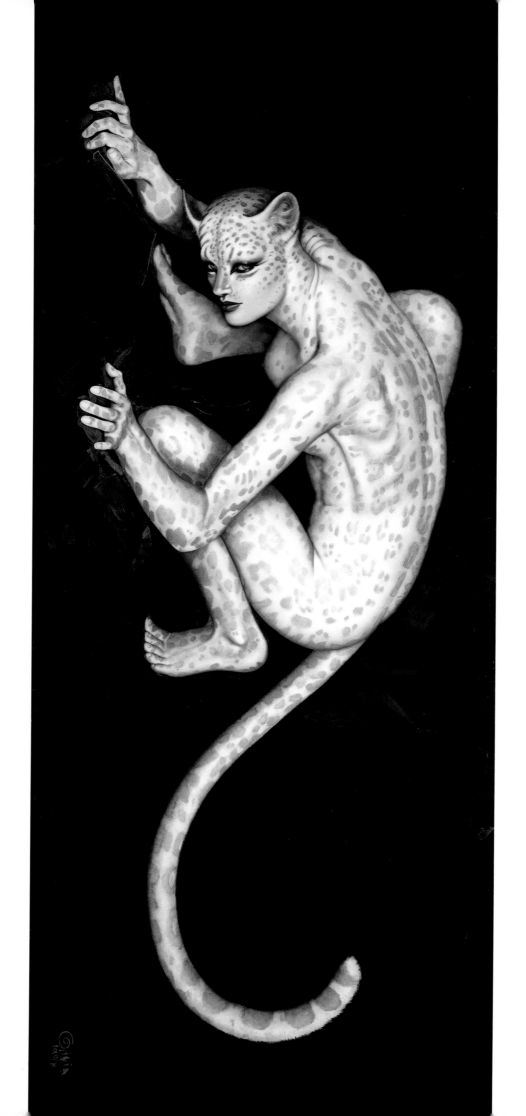

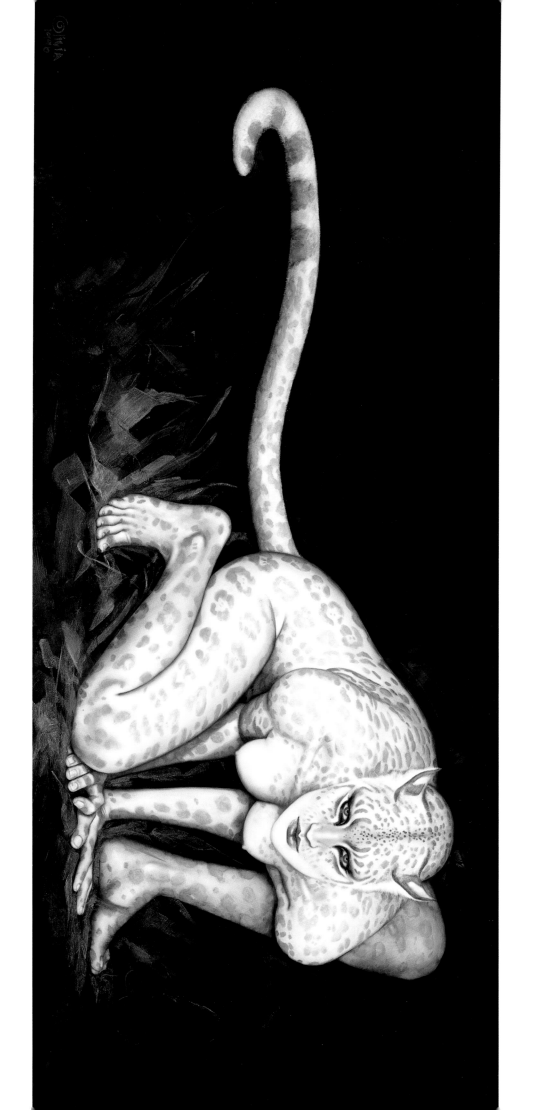

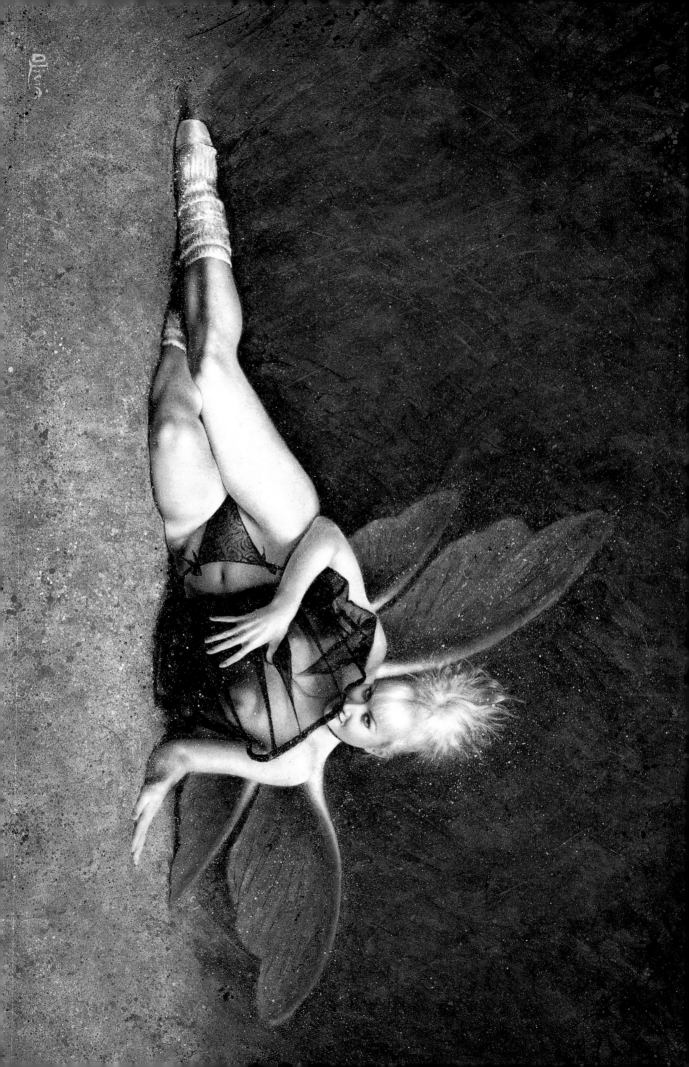

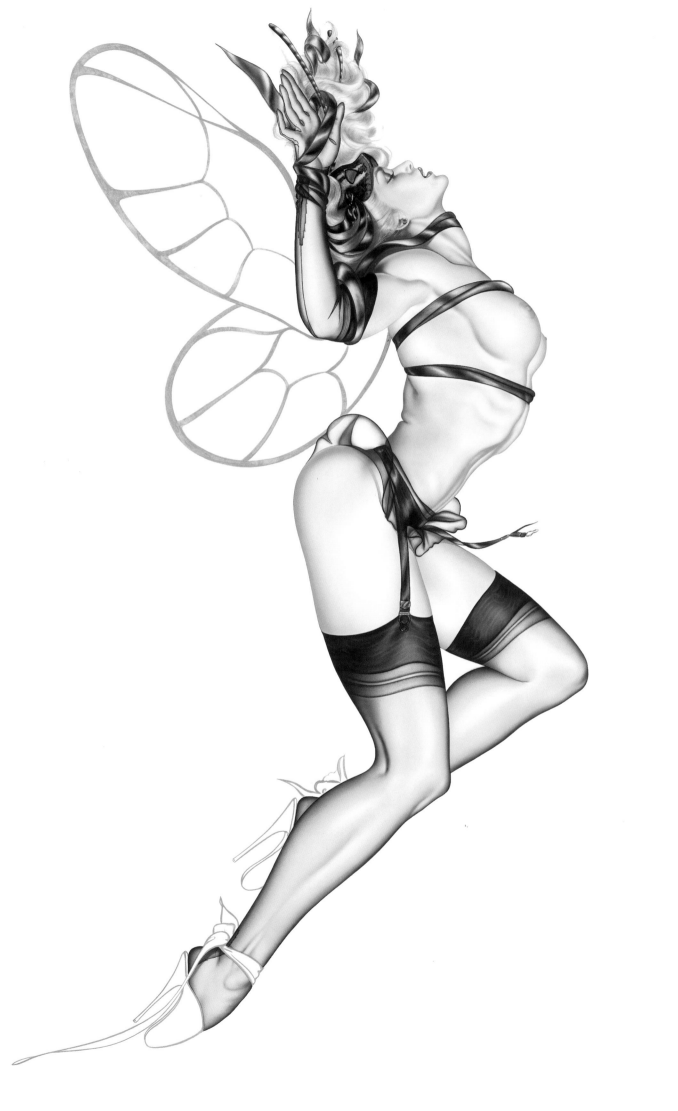

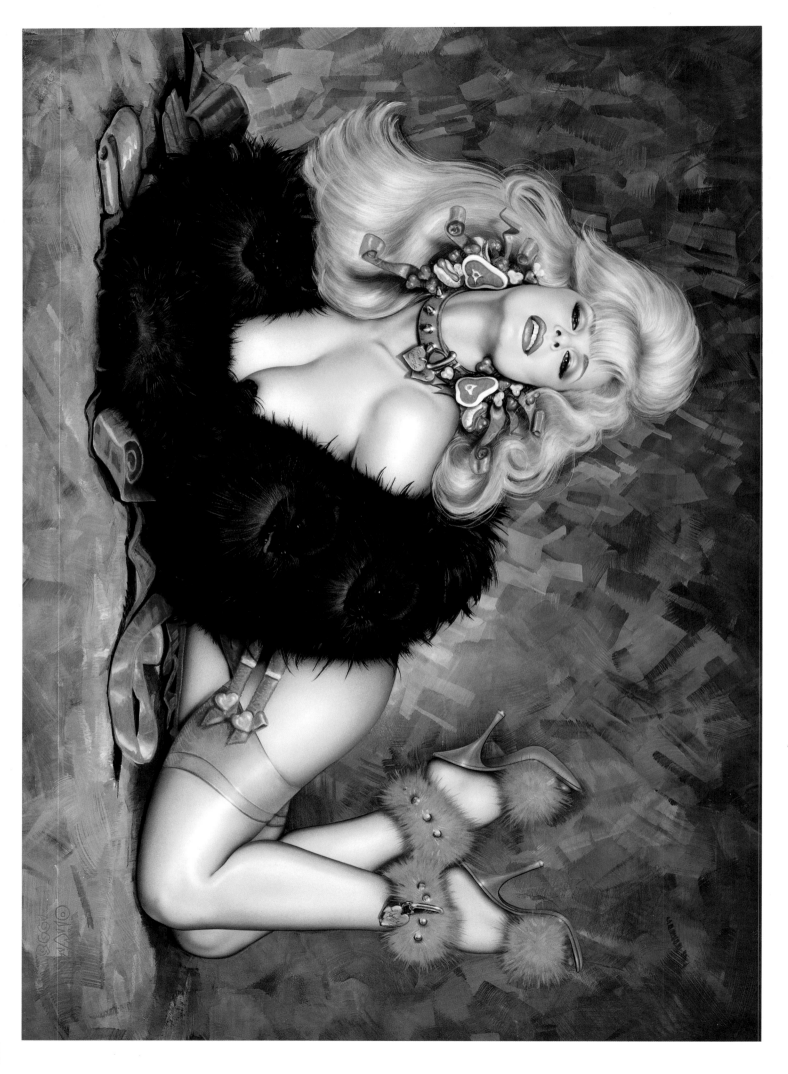

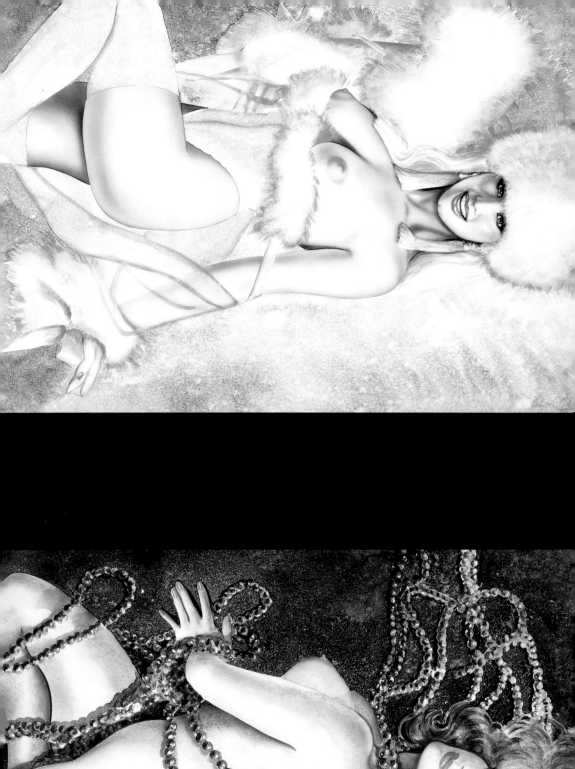
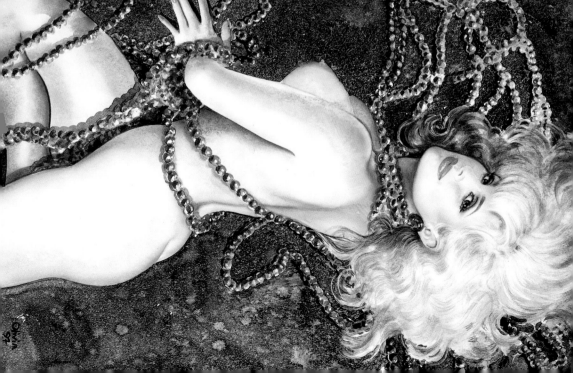

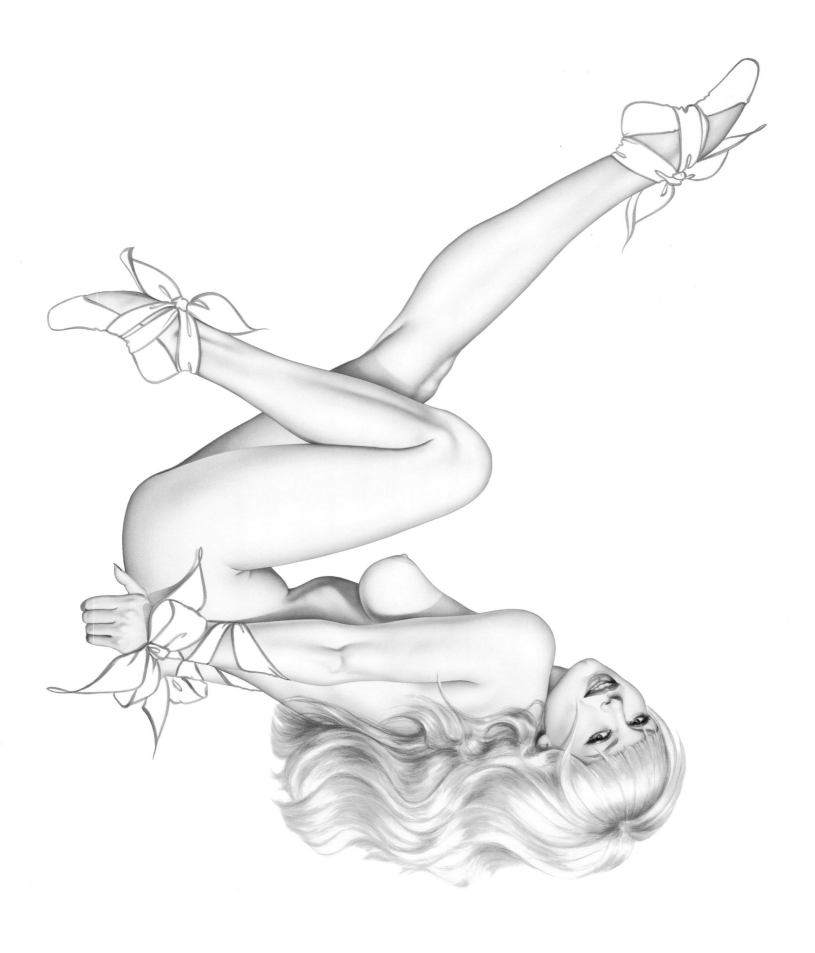

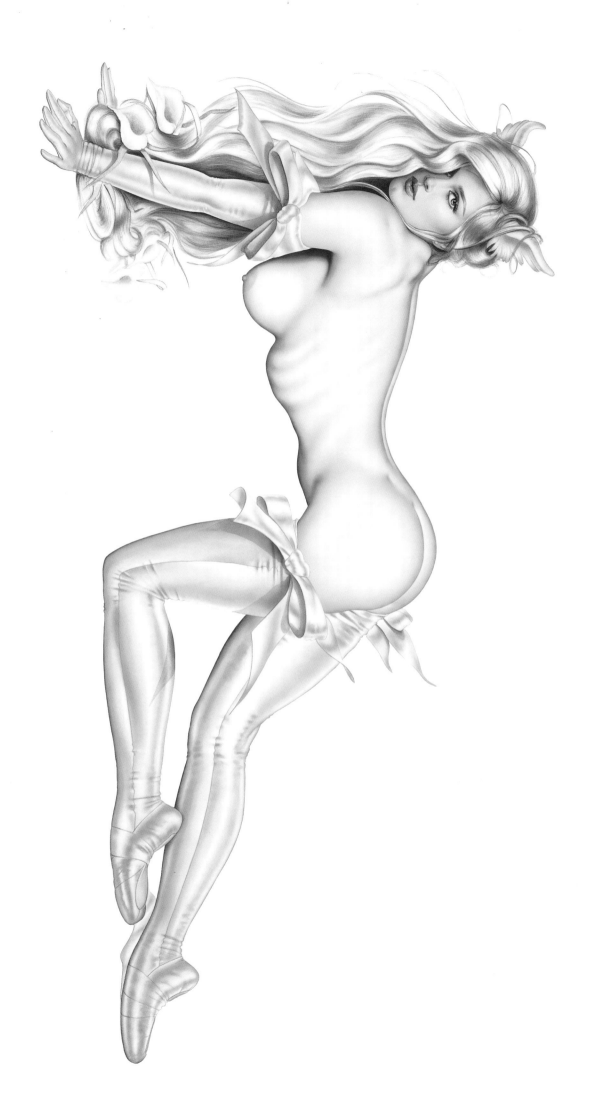

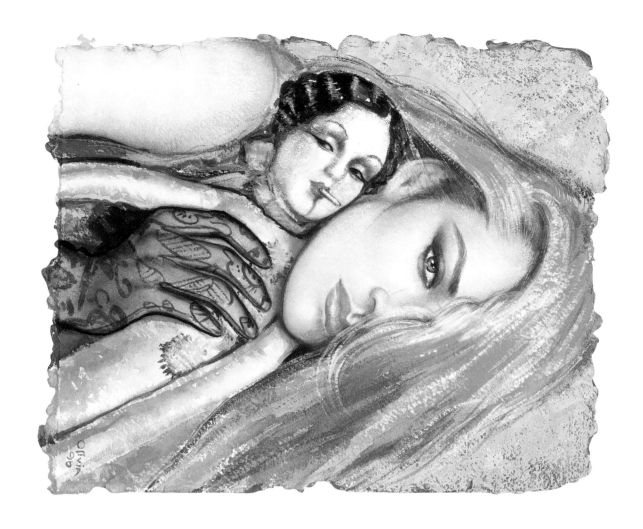

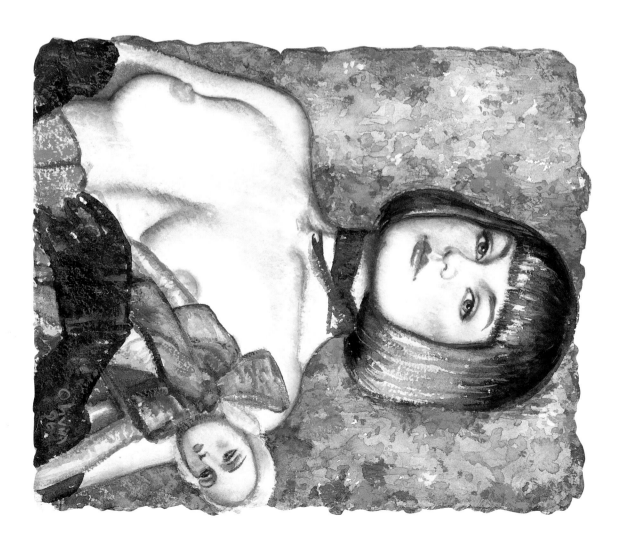

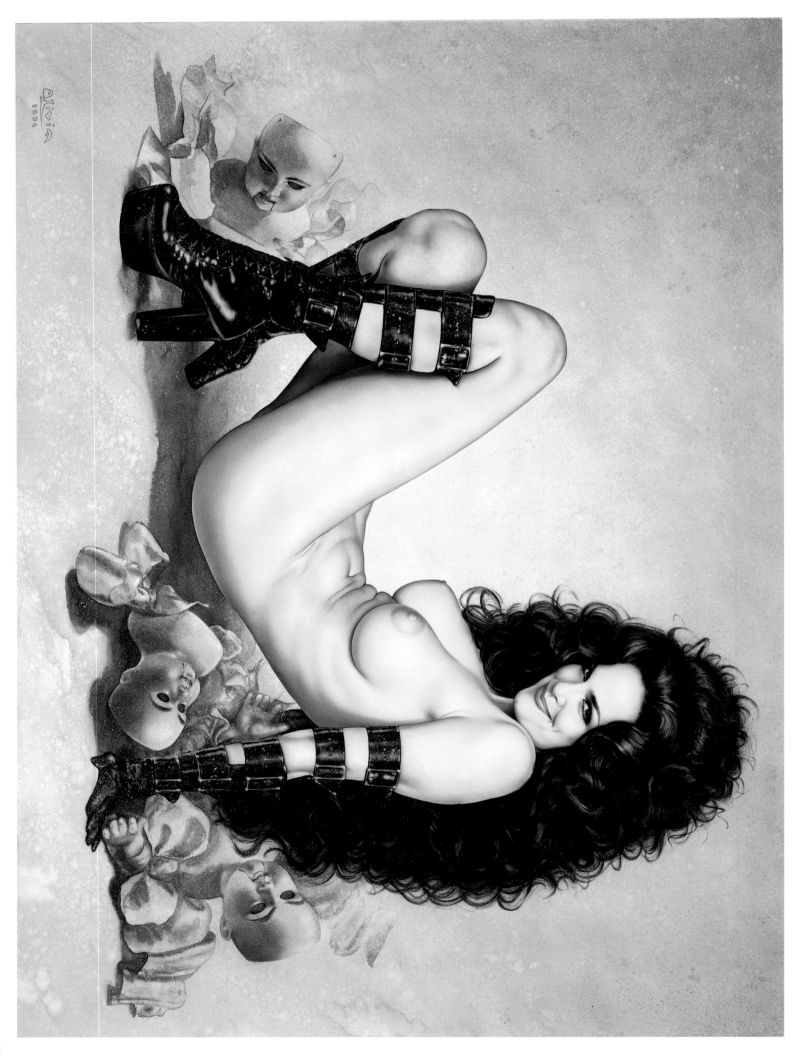

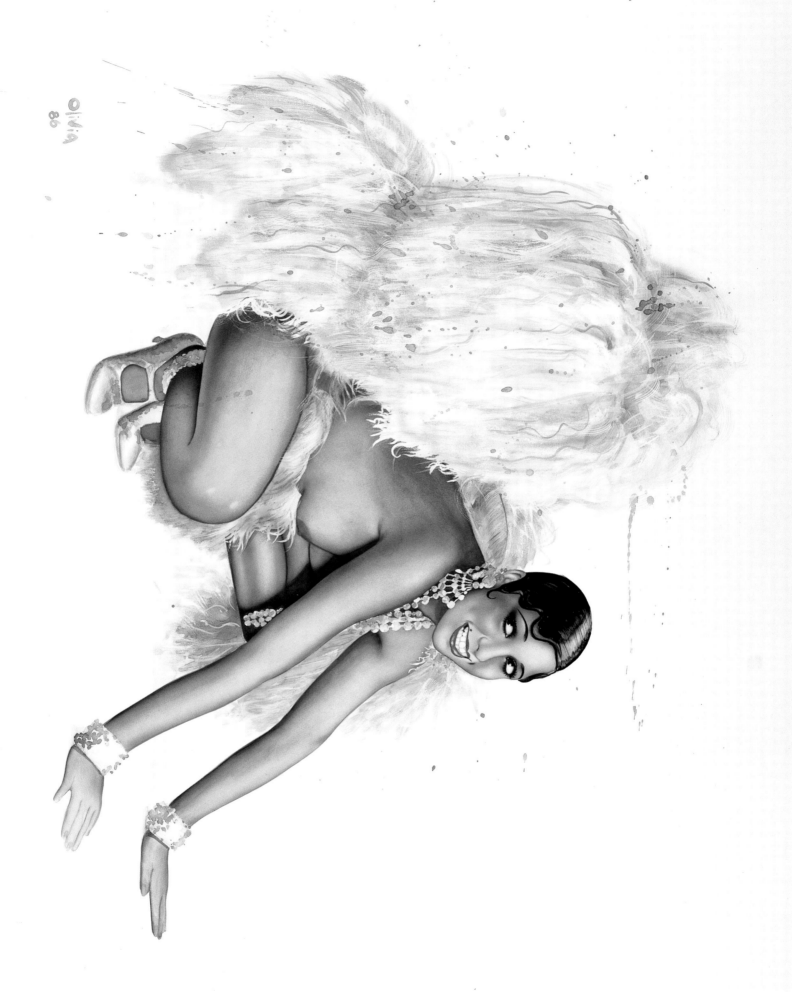

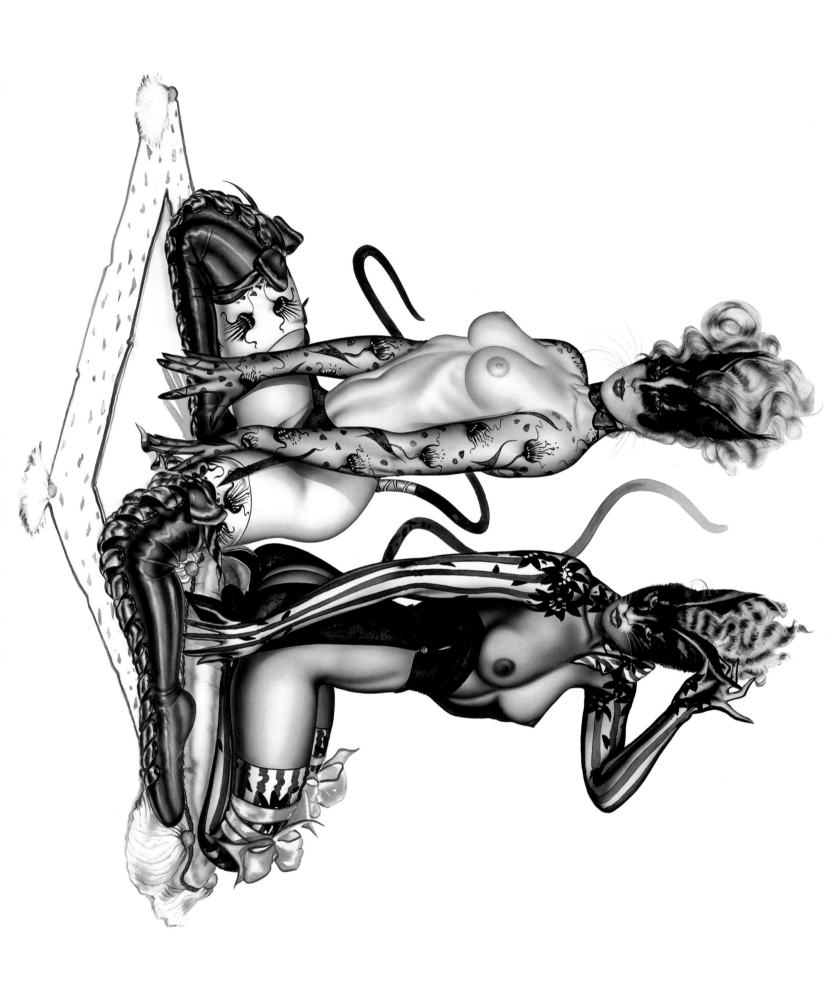

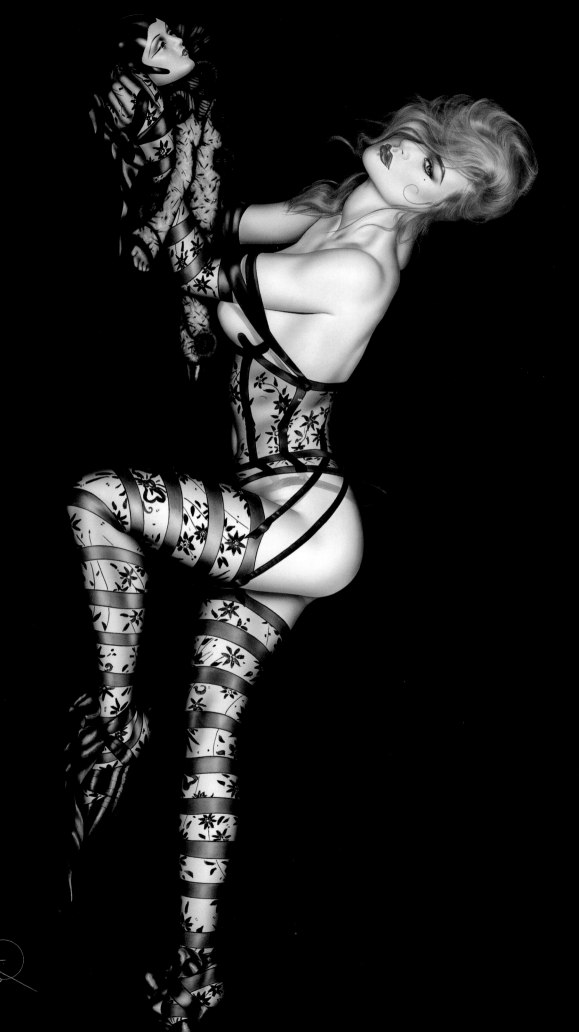

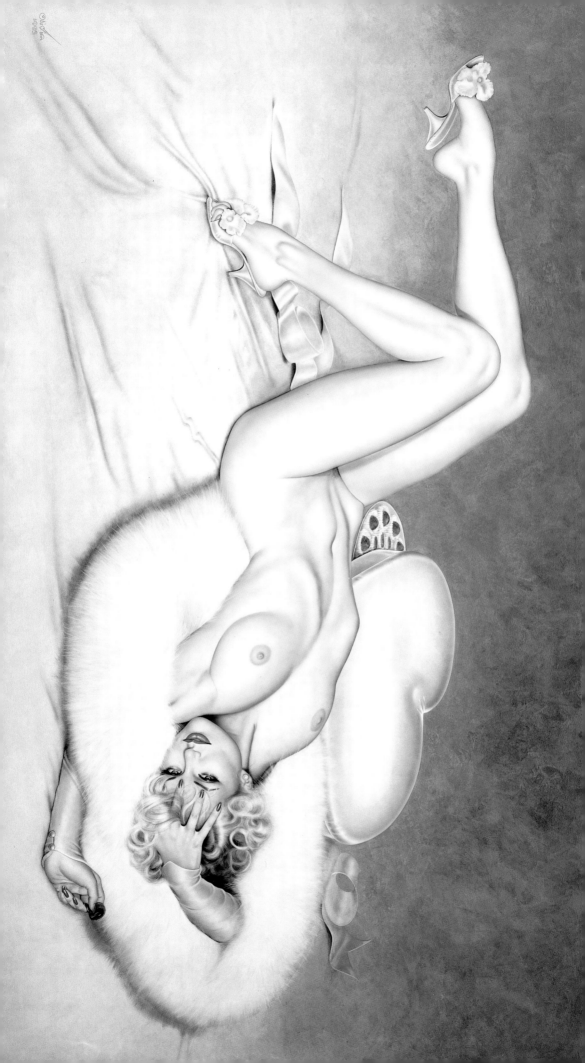

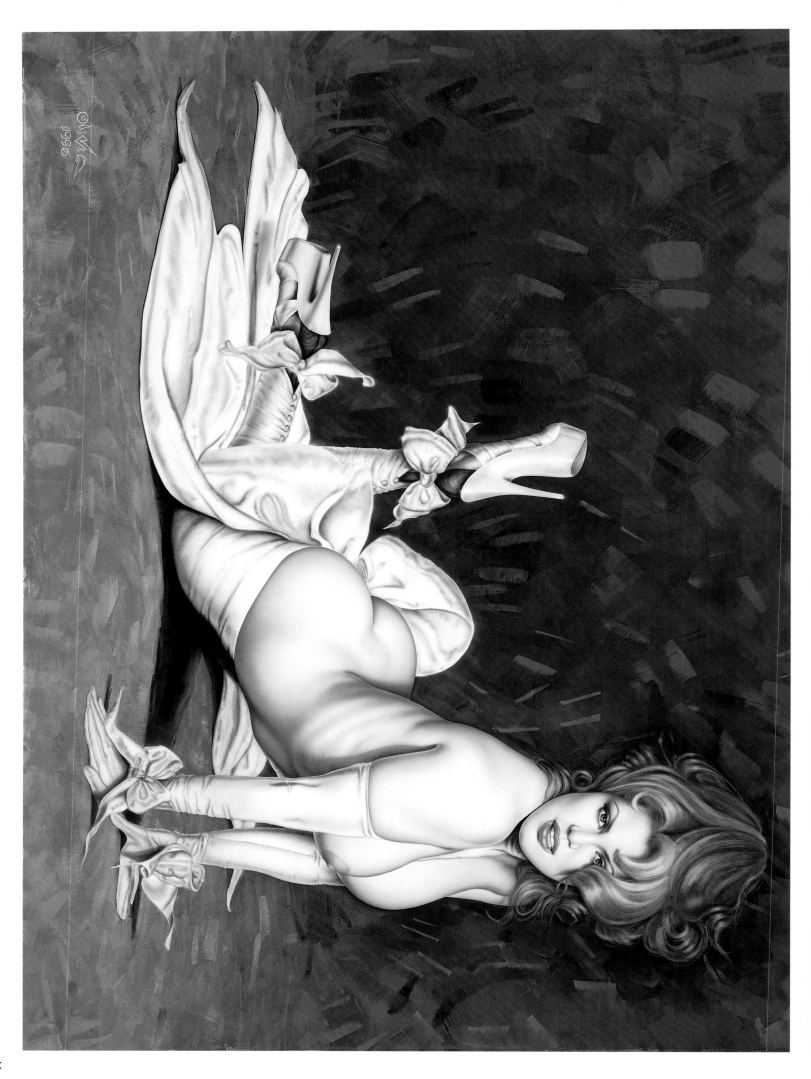

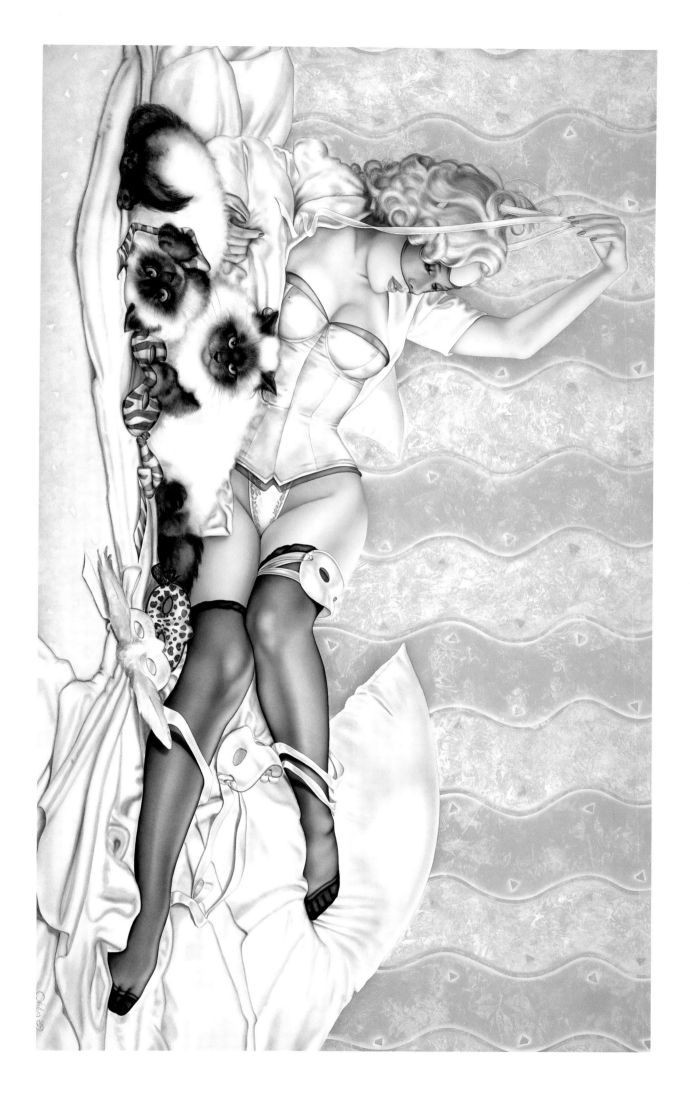

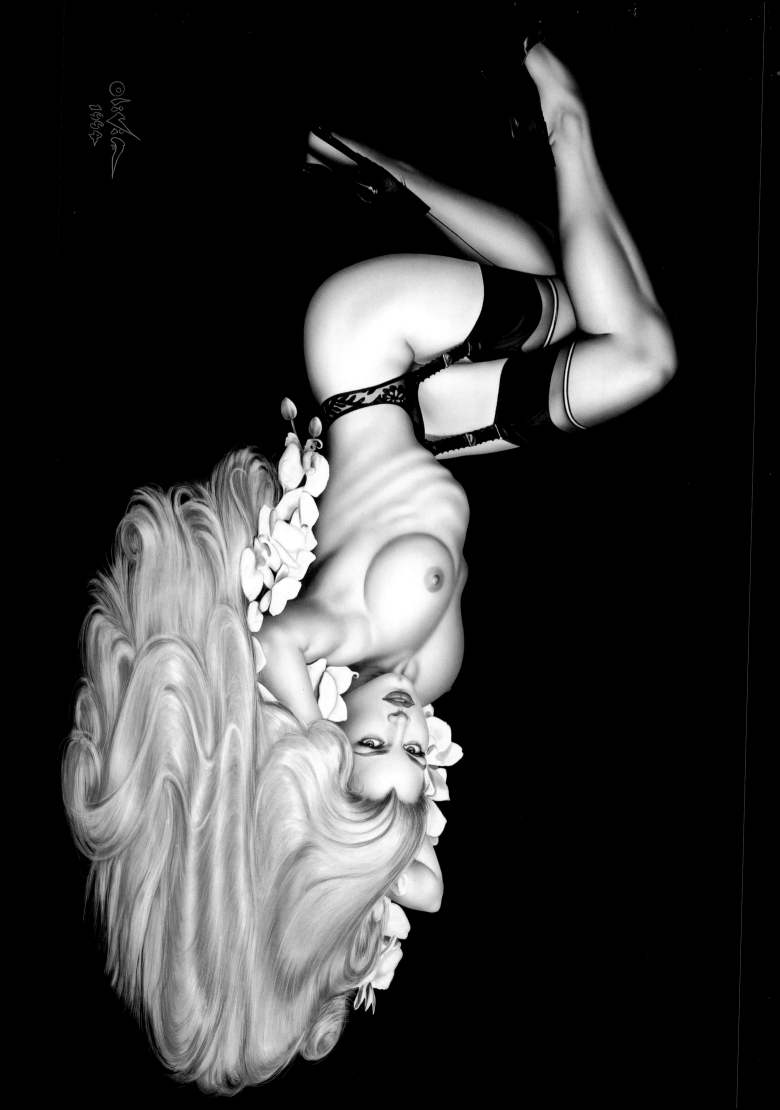

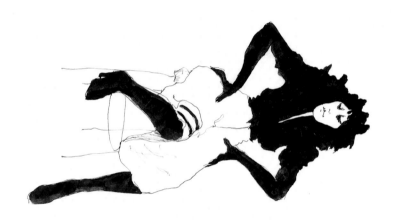

SECOND SLICE

The Art of OLIVIA

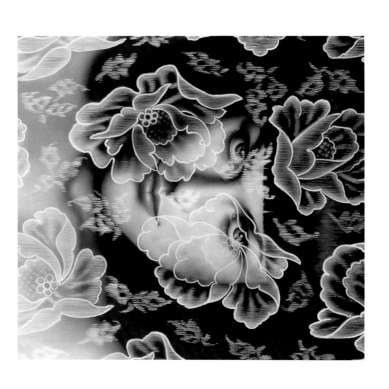

Ozone Productions, Ltd.